MICHAEL KLUCKNER'S
VANCOUVER

British Columbia in Watercolour (1993)

Heritage Walks Around Vancouver (1992, with John Atkin)

Paving Paradise (1991)

Vanishing Vancouver (1990)

Toronto the Way It Was (1988)

Victoria the Way It Was (1986)

Vancouver the Way It Was (1984)

MICHAEL KLUCKNER'S VANCOUVER

Text and Watercolours by Michael Kluckner

RAINCOAST BOOKS

Vancouver

FIRST PUBLISHED IN 1996 BY

Raincoast Book Distribution Ltd.
8680 Cambie Street
Vancouver, B.C.
V6P 6M9
(604) 323-7100

1 3 5 7 9 10 8 6 4 2

CANADIAN CATALOGUING IN PUBLICATION DATA

Kluckner, Michael.
Michael Kluckner's Vancouver

ISBN 1-55192-044-1

1. Vancouver (B.C.) – Pictorial works. I. Title.
FC3847.37.K68 1996 971.1'3304'0222 C96-910199-6
F1089.5.V22K68 1996

DESIGNED BY DEAN ALLEN
PROJECT EDITOR: MICHAEL CARROLL
COPY EDITOR: RACHELLE KANEFSKY

PRINTED IN HONG KONG THROUGH PALACE PRESS INTERNATIONAL

For Christine, my constant companion

Contents

ACKNOWLEDGEMENTS

Sally Maulucci and Andrea Davies encouraged me to consider subjects less obscure than those I had been painting. Sam Gudewill, Elaine and John Cumming, and Keith Sacré provided chairs on private property. Many others purchased paintings and agreed to loan them to the publisher. Matt Petley-Jones and Deirdre Hofer sold the paintings. Mark Stanton, Dean Allen, and Michael Carroll at Raincoast Books returned phone calls. My thanks to all of them.

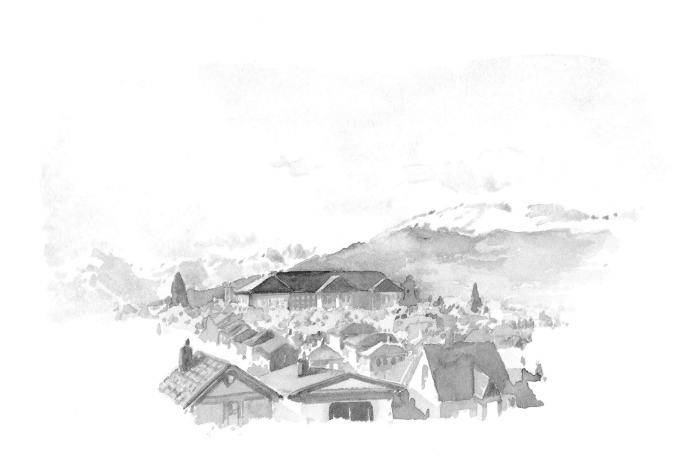

INTRODUCTION

Why should we not just disappear, separately, to
British Columbia, and have no scandal?
— Lady Chatterley to Oliver Mellors

A lot of people have been disappearing to British Columbia lately. Attracted by its booming economy while savouring its unusual combination of the urban and the natural, many have chosen to settle in the province's Lower Mainland. It appears that all the people who have been predicting greatness for Vancouver over the past century will finally see their vision come true. But the city's grandeur will not be due to its industrial greatness, as it was believed back in 1887 when the little mill town was linked to the rest of the world by the trains and steamships of the Canadian Pacific Railway (CPR). Instead, the city has become a curious combination of financial centre, trade centre, and home of the vaunted West Coast lifestyle, which attracts retirees and tourists who pump up the local service economy. It is a combination of the good life and the *goods* life that will see Vancouver glide prosperously into the 21st century.

Had D. H. Lawrence's Lady Chatterley and Oliver Mellors travelled to British Columbia to join Mellors's brother, they would have been part of North America's historic westward movement of people, a migration that had been under way for almost half a century by the time Vancouver was incorporated in 1886. International politics in the 19th century, with the Canadian Prairies still a fiefdom of the Hudson's Bay Company and the fertile West of the United States wide open to settlement, caused the development of the Canadian West to lag far behind that of the American states to the south. In 1870 Canada offered confederation to British Columbia and promised a railway to link it with the East. The offer, of course, was made for strategic reasons: the desire of central Canadians to be part of a sea-to-sea British dominion, and the need to forestall the periodic outbursts of American expansionism that had been reflected most strongly in President James Polk's Fifty-Four-Forty or Fight! campaign slogan in 1844. In any event, British Columbia became part of Canada in 1871; the railway did not reach tidewater until 1886.

Everything about the new West Coast province, including its isolation, difficult

EAST SIDE BUNGALOWS

In a city where few great churches have been built, schools often occupy the high ground. Norquay, towering above the jumble of bungalows on Slocan Street on the East Side, is one of many brick public schools erected in the boom years just before the First World War. On the West Side of the city, mature deciduous trees often conceal the continuous rooftops that are so characteristic of the East Side. During the early part of the 20th century, the latter was a separate municipality, specializing in low taxes and modest expectations, while on the West Side the popularity of the City Beautiful philosophy led to heroic tree-planting efforts. Similar modest expectations, and an apparent aversion to leaf raking, have made the newer bedroom suburbs to the south and east equally treeless.

ROOFTOPS AND MOUNTAINS

The pyramid roofs of the city's modest neighbourhoods mimic the peaks of the North Shore mountains. On Ontario Street, just south of King Edward Avenue, General Wolfe School stands across the street from bungalows built in the 1930s.

topography, lack of arable land, and bountiful resources, ensured that it would require large amounts of capital to get its natural assets to market. Very quickly a lot of that capital began to be controlled from Vancouver, and the British Columbia of forests and mines and fish became the closest thing in Canada to a society of capitalists on the one hand and a collective of workers on the other.

In the early years of the city's existence its potential for greatness was shouted from the treetops (there being, at the time, few rooftops). As in the American West, most of the business activity revolved around land sales, and every stump-strewn suburb had a newspaper that published a "progress edition," often quoting the slogan that Nothing Does a Town More Good Than the Wagging Tongue of an Optimistic Citizen. Some of the early industrial schemes were, in retrospect, so outlandish that Vancouver might have become a Pittsburgh on the Pacific. Typical were the forecasts in the *Vancouver Sun's* annually published booklet, *Industrial British Columbia,* which described the "New Industrial Empire on Canada's Pacific Coast, Strategically Located For World-Wide Distribution."

But because of its isolation and small population, Vancouver has always had trouble attracting industry, even though the city was established on a promising site for a rail terminus and ocean port. As long as there was a Canada – that is, a country north of the 49th parallel – there had to be a Vancouver.

Migrants flocked westward, bringing with them a desire to start their lives anew and quadrupling the population of the city in the first decade of the century. But as the years went by, and a cycle of depressions and wars followed the booms, many moved on. Some relocated to the United States, where they believed opportunity to be unfettered by fussy governments, and some returned to eastern Canada, where industrial jobs were more plentiful and less likely to succumb to an economic chill.

Most English-speaking travellers who wrote accounts of arriving in Vancouver were coming from eastern Canada, often to catch a steamer to Hong Kong and thence on to British India and the Suez on the "all-red route" – the transportation lines girdling the globe and passing through Britain's possessions, all marked in red on the maps of the time. In the late thirties Lady Tweedsmuir, who was the wife of the governor general known to readers around the world as the author John Buchan, wrote of passing through "great snow slopes painted all colours by the bright winter sunshine," and of being charmed to "wake up in Vancouver and see clumps of pussy willow in flower outside the train." Less charitable observers recall seeing from their first-class carriages the snowcapped mountains of the North Shore and, below them, the laundry lines and houseboats of squatters strung along the Vancouver waterfront – "the medley colony who live in dwellings built on floats consisting of stout planks laid across heavy logs that rise and fall with the tide," as the English writer Jasper Stembridge described them. As Vancouver's first underclass and a harbinger of things to come, the houseboaters in every bay of the harbour and slough of the Fraser River were the first non-Orientals to come to the coast who could not "make it" in the standard way. The last real squatters' community, which was home in the forties to the itinerant novelist Malcolm Lowry, survived on the Dollarton mud flats in North Vancouver until the early seventies.

Those who stayed in Vancouver, and got used to the wet winters, the cool summers, and the puttering indifference in which most people passed their lives, became quietly proud of their curious West Coast city. It was not a city of the Englishman's "quiet desperation," but rather one of shy contentment. "Canada" was something that largely happened somewhere else, except on wintry Saturday nights, when streets divided into Toronto Maple Leafs and Montreal Canadiens fans. The nearby Americans, who also got wet in the winter, had good selections of shoes and bed linens in their stores and, lacking the diffidence of Vancouverites, were perhaps a bit brash, flag-wavey, and fond of uniforms.

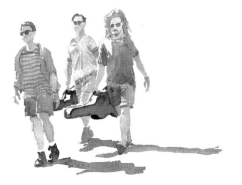

Longtime residents of Vancouver are used to the battle of expectations that is a constant theme of life on the West Coast. The Lower Mainland has never had the single-mindedness of an Ontario or a Hong Kong in the matters of business and development. Some people are boosters, what used to be called boomers – the sort of people who in 1910 strung a banner across Granville Street declaiming, MANY MEN MAKING MONEY MEANS MUCH FOR VANCOUVER! Others want to be left alone, like the hillbillies of West Virginia, and are content to work the minimum amount possible to get through the year and to have enough money left over to shop the seed catalogues in time for March planting. It is hard to say which type is the more advanced form of the human species.

Any discussion of life in Vancouver inevitably turns from real estate to the rapidly changing weather, and the English progression of the seasons that are unique in Canada to the West Coast. The intentions of true Vancouverites are rarely thwarted by it; a rainstorm may drive them inside for an hour or two, but when the front has passed over and the sky suddenly, miraculously, clears, they return to their gardens or outdoor games, or go for a walk to watch the soggy flowers lift their faces skyward again. An ideal winter is one with lots of

snow on the North Shore mountains and none at all in the city.

Although it is often stalled by hard rains or sudden snowstorms, spring is the time of year to live for. Crocuses, bulb irises, and some of the Japanese cherry trees bloom in January; February is often balmy and full of spring's promise; March sees drifts of daffodils and the high, luminous blue sky and banks of cumulus clouds of that particular season; April is showery but vibrant with the colours of a million rhododendrons and azaleas, while every meadow is carpeted with dandelions. In the Fraser Valley the swallows return. Springtime inches along, unlike elsewhere in the country, where the ground shakes itself free of deathly frost and suddenly explodes into leaf and colour.

In eastern Canada it always seems that the central heating is turned off the day before the air-conditioning is turned on. Traditional West Coasters, in their drafty wooden houses, were ignorant of air-conditioning and never worried much about heating their houses in winter because, as in England, it rarely got cold enough to kill you. My grandmother, writing a letter to her sister back east during the Second World War, expressed the hope that they would be able to get two units of sawdust rather than the one the authorities had guaranteed; if not, she wrote, they would have to wear an extra sweater indoors, for grandfather was too old to gather wood in the forest on the University of British Columbia's Endowment Lands and had only the streetcar to bring it home.

By comparison with the Vancouver of 30 years ago, the one today is a vibrant, multiracial, cosmopolitan place. Nevertheless, early travellers to the city found it to be a world crossroads, unlike any other Canadian city. Lady Tweedsmuir wrote: "Its partly oriental population makes it picturesque. Grave Sikhs with black turbans are to be seen walking in the streets, and stolid-faced Chinamen stand under cabalistic signs in front of their shops." She could have written a similar description yesterday.

After growing up in Vancouver and spending years involved in the minutiae of its individual buildings, I moved to a sheep farm in the Fraser Valley. A couple of years later I found myself appreciating Vancouver almost as a tourist, and I began to paint the scenes and views that I had long taken for granted. This book is a record of a year of such painting, all watercolours that I hope bear the stamp of the particular season and weather of days well spent outside.

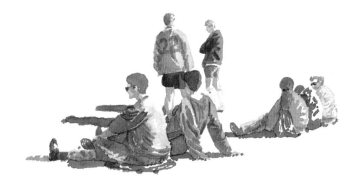

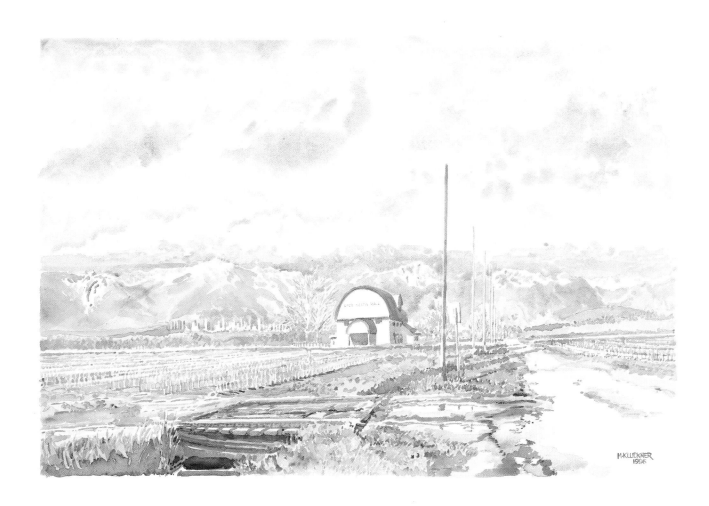

EAST DELTA HALL

From the flat delta lands south of the Fraser River, Vancouver's backdrop of blue mountains dominates the view to the north, as Mount Baker dominates the view to the southeast. Travellers from the United States can now see clusters of high-rises in the distance as they zip toward the city – not, however, the towers of downtown, but rather of the instant community of Metrotown in Burnaby, spawned by the commuter train line that opened in 1986. The old East Delta Hall, a relic from the days when community halls built by volunteer labour provided the social and political centres for farmers and farming concerns, still stands on the Ladner Trunk Road, a 19th-century route connecting Ladner with Cloverdale and Langley. In the spirit of rationalism and anonymity so characteristic of today, Ladner Trunk Road is now usually called Highway 10.

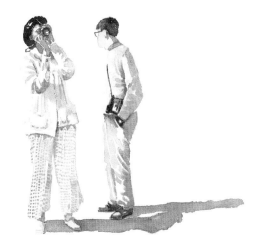

MODERN TIMES

Modern Vancouver could be said to date from the day in May 1969 when Mayor Tom Campbell climbed onto a wrecking ball, with his hard hat in his right hand and his left arm securely around the cable, and waved to the assembled press photographers. The "photo-op," one of a slew of publicity stunts on which the mayor thrived, was to start the megaproject at Georgia and Granville Streets now known as Pacific Centre. The wrecking ball, which in previous years had not been overly active in Vancouver, was about to knock down the 1891 Vancouver Opera House, known then as the Lyric Theatre.

For the previous 40 years, from the day in 1929 when Mayor W. H. Malkin blew a golden whistle to start construction of the Marine Building at Burrard and Hastings Streets, the city had been changing only by fits and starts. In fact, the word *changing* is probably a bad choice, for the city had undergone a sea change socially; the issue in the 1960s was whether the city was *progressing*.

Some money had been spent in the intervening years on the downtown, including the dismantling of the city's streetcar and interurban systems, the opening of two automobile bridges to the North Shore and two across False Creek, the construction of Ayn Randish public-housing complexes in Strathcona, and the erection of a few office buildings south of the waterfront along Burrard Street. However, Vancouver suffered from its isolation and lacked industry of the Toronto sort, which built consumer durables like cars and washing machines and fridges, and was almost recession-proof. According to its business community, Vancouver was lagging behind the other cities in North America, where freeways and office parks and a whole new way of life had evolved in the freewheeling fifties. As the newspapers of the time put it, Vancouver could seize its future and, besides, there was a lot of money to be made.

In the sixties the established downtown of terracotta-faced office buildings, supplemented here and there with enamel and glass-faced newer buildings

(such as the United Kingdom Building at Granville and Hastings, and the B.C. Electric Building at Burrard and Nelson), was pushing only half successfully against the ring of old houses, parking lots, auto-repair shops, churches, and cheesy nightclubs that were the residue of an earlier age. Buildings had been deteriorating so slowly, for so many decades, that it was hard to imagine a future day when they would finally be gone.

We were teenagers, and when we weren't at the beach or at the Village Bistro on Fourth Avenue, we hung around Granville Street downtown. Especially on Friday and Saturday nights (for the town was shut up as tight as a clam on Sundays), with the neon of Theatre Row reflecting off the wet side-walks and tinting our faces and clothes, we lined up for movies or played pool at the Orillia or Seymour Billiards. All of Vancouver's excitement, such that it was, happened on the garish strip of Granville Street south of Georgia, and in the darkened, glistening side streets that crossed it.

To the rescue came Tom Campbell, Q.C., mayor of Vancouver from 1968 to 1972. With his astounding ability to attract publicity, even his haircut (descending sideburns and lengthening ducktail as the sixties progressed) mer-ited photographs and discussion in the newspapers. As a developer, he had made his fortune building apartment blocks, including the ugly ducklings bracketing Burrard Bridge – at the Kitsilano end, Parklane Towers, with its mossy swimming pool and screen-brick fencing; on the West End side, the roundish Martello Towers, the balconies of which were soon storing all the chattels that couldn't be stuffed into the tiny apartments.

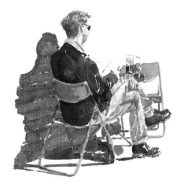

Campbell believed passionately in redevelopment as the tool to re-create the city and had little time for anyone who protested being left out of the process. Like his contemporary Bill Vander Zalm, who was at that time the mayor of Surrey, he was a forerunner of the politicians of the 1980s; in the words of *The Financial Post,* Campbell was reelected in 1970 on a "law-and-order, anti-hippie platform." He was dubbed "Tom Terrific" but soon became an object of scorn to the *Vancouver Sun* which, in the long run, brought about his downfall.

Campbell and "the hippies," by which he meant his opposition, were as mutually dependent as rhinos and the birds that groom them. Although his support for projects such as Pacific Centre bore fruit, he came a cropper in supporting the C P R's Project 200, an undertaking that aimed to redevelop most of Gastown and the waterfront freeway and Third Crossing that were, in large part, to service it. He was the best target any civic opposition group any-where could have hoped for: in the spirit of the time, street demonstrations (like the Gastown Smoke-in), parties at English Bay, and Ho Chi Minh posters that hung in the Beatty Street Armoury when it operated as a youth hostel all led to a predictable overreaction from him. When Canada was briefly under martial law during the October Crisis of 1970, Campbell suggested that the new police powers might come in handy in Vancouver.

The climax of the period, in my memory, came on January 9, 1972, a cold, grey Sunday, when a motorcade of shiny cars full of politicians from all govern-ments marshalled itself at the east end of the Georgia Viaduct. They were prepar-ing to drive across the viaduct to celebrate its opening. At the downtown end stood a placard-wielding throng of protesters and street people, many with long hair and beards, who were convinced that the viaduct, the first phase of a freeway

system, was the thin end of the wedge. A group of us from the U B C militant cyclist's club – I can remember no other name – who already had to our credit the plugging of University Boulevard to agitate for cycle paths on campus, formed a chain across the viaduct directly in the path of the motorcade.

Leading the dignitaries was a Vancouver police force motorcycle phalanx, which stopped briefly in front of our chain before pushing directly into it at the bicycle behind mine – my girlfriend's, who probably wished she were somewhere else. She moved, but another cyclist did a Gandhi and had to be hauled away. Although his example was followed by others, eventually the motorcade made it through. That night all the newscasts decried the protest as the work of thugs, agitators, and troublemakers.

The following day the mayor wrote a number of letters, carbon copies of which survive in the city archives. One, to the superintendent of the police traffic division, stated: "Just a note from myself and Mrs. Campbell to express our appreciation for the excellent manner in which the motorcycle officers handled the disturbance at the opening of the viaduct." Another, to the Most Reverend James Carney, archbishop of Vancouver, who was riding with the Campbells in their Pontiac sedan, said: "I would apologize for the disrespect shown yourself and your office by some of the citizens of Vancouver. I am certain that you are aware that this is only the opinion of a very, very small minority."

On the last point the mayor soon realized he was wrong. Opposition grew and, on February 9, when it was clear that he had lost the support of some of the surrounding municipalities, the senior levels of government, and even some of his council, he lashed out at the "Maoists, communists, pinkos, left-wingers, and hamburgers" who were standing in the way of progress. Not long afterward rumours began to circulate that he would not seek reelection.

In the long run Campbell's tirade, his replacement by the moderate administration of Art Phillips, and the aroused "militanti" have caused Vancouver to muddle along and to progress more slowly than those of Mayor Campbell's ilk would have preferred. This is not to imply that there has been an end to huge projects – the C P R's Coal Harbour development and the Concord Pacific scheme on False Creek being two obvious examples – but politicians and planners were no longer believed when they claimed to have all the answers. The rule of the experts, who could plan, design, finance, and build a satisfactory new city on the rubble of the old one, had ended. On television the new mood even brought down the reign of men in white coats who told women how to get their laundry clean.

The saga of Birks Jewellers, which for more than 80 years occupied the southeast corner of Granville and Georgia, is something of a cautionary tale from that era. Based originally in Montreal, Henry Birks and Sons expanded across Canada, usually taking over established local jewellers. In Vancouver the company bought Trorey's, which operated from a two-story brick building at the northeast corner of Granville and Hastings. In 1913, at the height of Vancouver's Edwardian-era prosperity, Birks moved to an exquisite, curved-fronted tower at Granville and Georgia – across the street from the prestigious Hotel Vancouver and the Hudson's Bay Company – at what had become Vancouver's premier corner. It took with it Trorey's old clock from Granville and Hastings.

By the late 1960s Birks had expanded into suburban shopping malls and decided to redevelop its site as part of the Vancouver Centre downtown mall, connected underground with the Pacific Centre and the Bay. Down came the old building and its neighbour to the east, the Strand Theatre. Up went a huge tower for the Bank of Nova Scotia on the site of the Strand and an unprepossessing, single-story structure on the site of the old jewellery building. The new Birks, clad in cold brown marble, looked like a suburban mall operation and was never the anticipated success. Over the years the company's fortunes foundered, and only the Vancouver habit of "Meeting at Birks Clock" remained firm. When an Italian company purchased Birks in the 1990s, it promptly rejected the Vancouver Centre as a site from which to sell prestigious jewellery. So down Granville Street went Birks again, settling into the restored Bank of Commerce Building at the corner of Hastings and Granville, just across the street from the site of Trorey's. The clock, of course, moved, too.

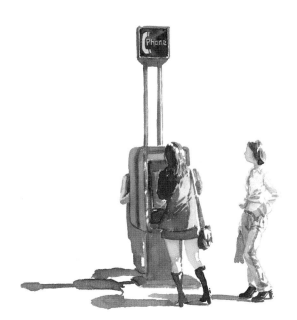

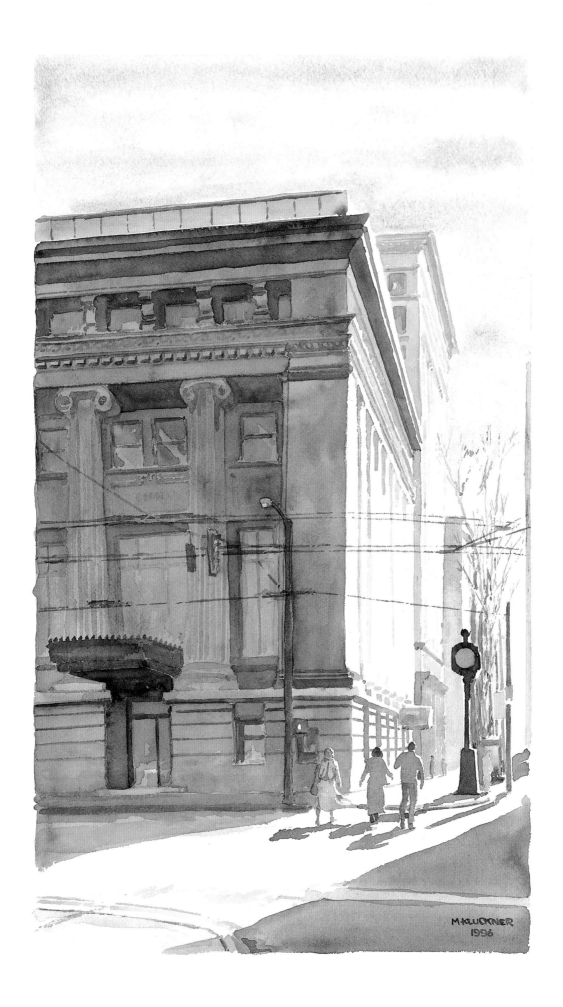

BIRKS CLOCK

At the corner of Granville and Hastings, on a bright winter day, the Birks Clock heralds the return of shopping to the old downtown – Vancouver's commercial heart at the turn of the 20th century. The clock, which started life marking time for Trorey's Jewellers on the northeast corner of the intersection (the one in the foreground of the painting), went uptown with Birks in 1913 and returned 80 years later when Birks decided to restore the old Bank of Commerce building rather than keep its oar in with the Vancouver Centre and Pacific Centre malls. With its Ionic columns, the bank building is a successor to the pagan temples of ancient civilizations, which is appropriate.

FOLLOWING PAGE

THE WATERFRONT FROM STANLEY PARK

On rainy days the modern towers of downtown Vancouver and the "sails" of the Trade and Convention Centre on the waterfront lose their pushy, me-first angularity and seem to hang in the misty air. Also muted in the dull light are the Chevron and Petro-Canada signs on the gasoline barges in Coal Harbour, a feature of Vancouver's waterfront for generations. At this point a walker proceeding in a counterclockwise direction around the Stanley Park seawall has left the yachty clutter of inner Coal Harbour behind; Deadman's Island, on which stands the naval cadets' station known as HMCS *Discovery* (visible in the middleground of the watercolour), was a burial ground for the Squamish nation until European colonization began in the 1870s.

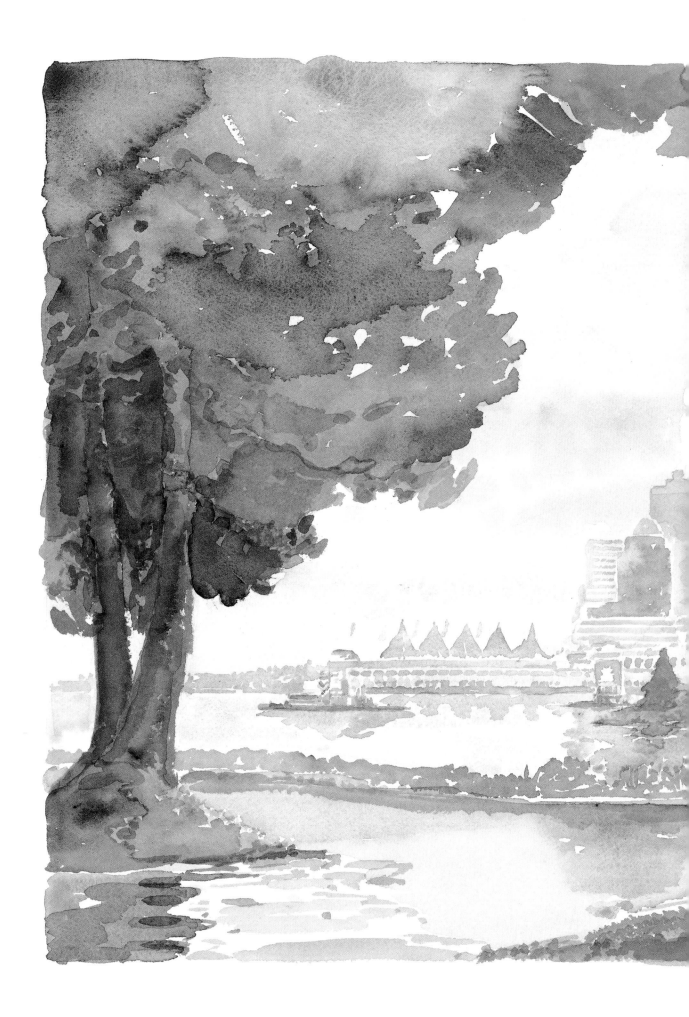

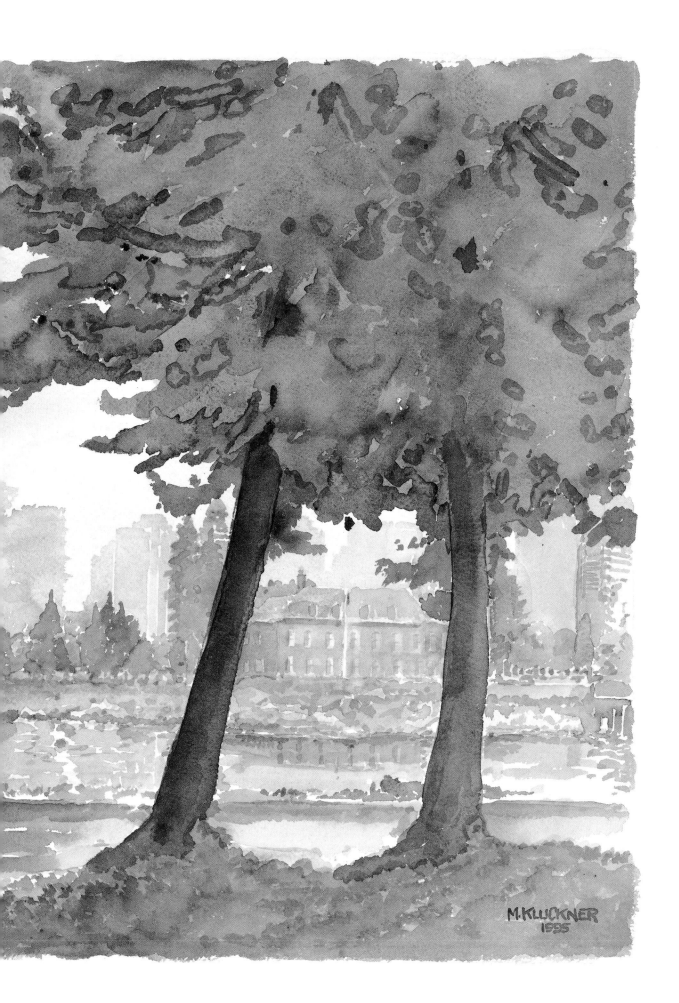

M·KLUCKNER
1995

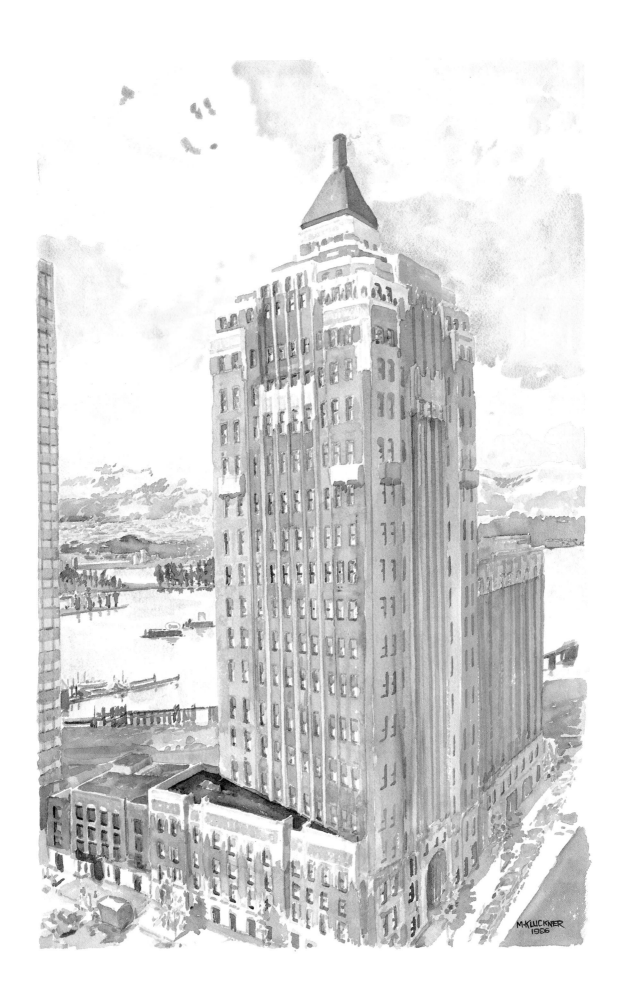

M·KLUCKNER
1996

PREVIOUS PAGE

IACI'S ETC. ON SEYMOUR

Parts of old Vancouver have been deteriorating so slowly, for so many decades, that it is hard to imagine a future day when they will finally be gone. The four houses on Seymour Street between Helmcken and Nelson, survivors from a time when the area south of Georgia was residential, have gained a curious landmark status, in no small part because of the numbers of people who travel by car along Seymour, the northbound route into downtown. For Vancouverites of a certain age, the farthest house along was a cultural landmark, due to the long-term tenancy of a restaurant called the Casa Capri but usually known simply as Iaci's, after the proprietors; in the "bring your own bottle in a brown bag, hide it in the shelf under the table" era, when there were few restaurants in the city, it gained a loyal following. Equally famous was its across-the-street neighbour, the Penthouse Cabaret, a beacon for showgirls, stripteasers, and call girls in an era before every beer parlour had strippers and every street corner (especially in this area) featured prostitutes.

OPPOSITE

MARINE BUILDING

The Marine Building, at the corner of Burrard and Hastings, is *the* great monument surviving from the city's second economic boom – the post-Panama Canal, 1920s one that established Vancouver as a significant grain port. Ironically it was built by developers from perfidious Toronto, although they did at least employ a firm of local architects, unlike many other eastern institutions (such as the Bank of Commerce, which erected the building now occupied by Birks Jewellers). Begun in 1929, a time, like the 1980s, when it seemed as if the bull market would go on forever, the Marine Building opened into a world of soup kitchens and hobo jungles, a Vancouver version of New York City's "Empty State Building." After languishing untenanted while the bankrupted developers sought a buyer at a fire-sale price, it was purchased by the Guinness brewing interests, which were investing in countries far away from the unstable European cauldron. In the mid-1930s Guinness financed an automobile crossing of the harbour's first narrows (the Lions Gate Bridge) and an exclusive subdivision (the British Properties) high on West Vancouver's Hollyburn Ridge. The latter, like many of the city clubs of the time, was exclusive in the sense of being exclusionary; I remember, as a boy in the 1950s, the list of prohibited racial and religious groups on the sign at the sales office on Taylor Way. The Marine Building stands on the edge of the escarpment above Coal Harbour's tidal flats. At the time I painted it only a few wharves and pilings remained along the shore, although the working harbour was once centred there. The gasoline barges visible in Coal Harbour have acquired the respectability of age – the first one opened for business in 1917. In the middle distance is the edge of Deadman's Island, and Stanley Park, at that point little more than a peninsula extending out to Brockton Point. New developments at the end of the 20th century will insert a row of residential and office towers between the Marine Building and the water, completing the transformation of the city's historic harbour from its salad days of shipping and muscular industry to a new age of grey-flannelled finance, tourism, and luxurious urban residences: travesties in travertine and serviceable villas.

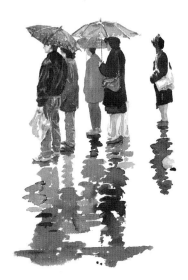

WHERE THE SMART SET MET

Before downtown Vancouver became "world-class" and most of its glitter shifted to Canada Place and the waterfront, its fashionable centre was the hotels on Georgia Street between Granville and Burrard. Soon after 1886, when the Canadian Pacific Railway built the first Hotel Vancouver on the ashes of the infant city's great fire, the corner of Georgia and Granville had become the centre of Vancouver's little universe: streetcars lined up in front of the Opera House on Granville to whisk away Vancouver's culturati after performances by the likes of Sarah Bernhardt and Anna Pavlova; between Howe and Hornby Streets, Court House Square was the scene of ceremonial spectacles for king and country; couples met under the Birks clock, dined at Scott's, took tea at the Bon Ton, danced and dined at the Georgia Hotel, and entered the Hudson's Bay Company past its uniformed doormen. Lesser mortals hung around the corner, gawking at the cars coming and going, or wandered south to take in a film along the "great white way" of Theatre Row.

Only the well-dressed and -heeled entered the Hotel Vancouver at Georgia and Granville where, before the First World War, titled German investors mingled with the resident ladies and gentlemen; in 1936, at the height of the Great Depression, the industrialist Austin Taylor held an "at home" there for several hundred acquaintances. It is not stretching credulity to say that Vancouver then had both its masses and a small cadre of "aristocracy," a situation that all the efforts of all the gossip columnists of today cannot replicate.

In the aftermath of the Second World War Georgia Street entered a new, more democratic era. The new hotel of the Canadian National Railways (CNR) on the west side of Court House Square had opened in 1939 as the Hotel Vancouver, following some deft financial and legal sleight of hand between the CNR and its arch rival the CPR; it replaced the latter's Hotel Vancouver on the east side of the square. The old hotel, which had been during the twenties and thirties a symbol of exclusive, unobtainable wealth, closed and stood all but abandoned during the war. However, in the housing crisis following demobilization, it was "liberated" by returned servicemen, led by a soldier who later

became the minister of health in the provincial government of the common man – the Socreds. In 1949 the old hotel was demolished, ostensibly to be immediately replaced by a new Eaton's department store.

Instead, with the economy flat in early-1950s Vancouver and the country's interest focused on Korea and the Cold War, the site became a parking lot, and the real Vancouver – the one of poor families and seasonal work – crept closer to the former magical corner. Behind the Court House, across Robson Street, stood the Alexandra Ballroom, nicknamed "The Gonorrhea Track"; nearby were a few storefronts, one of two downtown liquor stores, and some small apartments and houses interspersed with parking lots.

The atmosphere of those days still seems to cling to the old hotels that survive around Court House Square: Dal Richards playing at the Panorama Roof of the Hotel Vancouver; the Grey Cup riots of 1955, 1963, and 1966, when football fans staying at the Hotel Georgia tossed glasses and bottles onto the violent crowd below, a man was arrested for scaling the Devonshire Hotel to rip down its Canadian flags, and 60,000 people, many drunk, thronged Georgia Street between Howe and Burrard "in scenes reminiscent of v e and v j days"; big, cigar-smoking men wearing white shoes attending the Truck Loggers Convention at the Hotel Vancouver; the Cave Supper Club on Hornby, with Mitzi Gaynor visible on stage through a fog of cigarette smoke; nightclubs where patrons brown-bagged their mickeys and slotted them into shelves under the tables; and the gentle Devonshire, razed in 1981, where ladies visiting the city for the day might take a room to freshen up between bouts of shopping, and the beer parlour was quiet and almost refined.

For a centennial project in 1967 Court House Square gained a fountain, in the centre of which is a sculpture featuring Celtic maidens clawing their way up slick cliffs of granite toward daggers imprisoned in the stone. While it was under construction, the hoarding surrounding it became the city's first "paint-in" – an explosion of colourful creativity in sharp contrast to the machinations going on across the street, which culminated in the development of the Pacific Centre Mall. On a rainy night in December 1966, three hours after the fountain was opened by Premier W. A. C. Bennett, a passerby unofficially christened it with a box of detergent. A regular on the Court House steps was Joachim Foikis, Vancouver's town fool, with his band of flute-playing, flower-strewing followers and his donkeys Peter and Pan pulling an old wagon through the city streets – financed, incidentally, by a $3,500 Canada Council grant.

A new court house, part of the provincial government's Robson Square complex, went up on the two blocks south of the old one in the mid-1970s and signalled a new, less monumental direction for downtown. Ironically it also spelled the demise of the old Court House Square: in 1983, when the Vancouver Art Gallery took over the old courthouse, the architects chose to orient the gallery toward the southern, Robson Square side, leaving the Georgia Street side bereft, with its grand stairs leading only to locked grillwork.

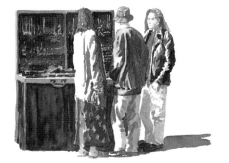

On the south side a fantastic array of stairs that would do credit to an M. C. Escher engraving lead up from Robson Street and the subterranean part of Robson Square to the gallery. These new steps are in the sun, making them ideal for chess games, protest demonstrations, and the recumbent youth who dot them like starlings on country telephone wires.

To the west, on the retail blocks of Robson Street, there is now nothing left of the bratwurst-and-beer atmosphere of 1960s-era Robsonstrasse; with the demolition of a number of old storefronts, all physical evidence has vanished of this early incarnation of cosmopolitan Vancouver. However, the active street life that began to captivate Vancouver 30 years ago has more than survived, its new mecca the corner of Robson and Thurlow, bracketed by twin Starbucks coffee shops. The street life is a mixture of local people from the West End; tourists, many of them chic and Oriental; tough kids in grunge clothes who ride the SkyTrain in from Surrey; and the homeless. It has become the place of choice for a riot – as witnessed by the Stanley Cup hangover of 1994 – while Georgia Street has been left in peace.

NELSON STREET

A walker on Nelson Street, travelling east toward Burrard, passes through all the stages of the West End's development in a half block. Visible are the edge of a 1940s apartment, two family houses from the beginning of the 20th century, and on the corner of Burrard the stone First Baptist Church, a solid relic from 1910, which was still a pious age. Across Burrard stands another relic: the old B.C. Electric Building, a skyscraper erected in the 1950s on the site of some frame houses, much like the one in the foreground, one of which was a dressmaking operation, another of which was reputedly a brothel. In the years since its construction, the skyscraper has seen some changes – it is no longer "Grauer's Power Tower" (named for the utility's president), brightly lit night and day to trumpet the abundance of cheap electricity available to the young families setting themselves up in far-flung bungalows. Instead, it has been converted into compact, affordable condominiums for a new generation with comparatively modest, urban expectations. The utility company, now B.C. Hydro, needed a bigger building and went elsewhere to erect it.

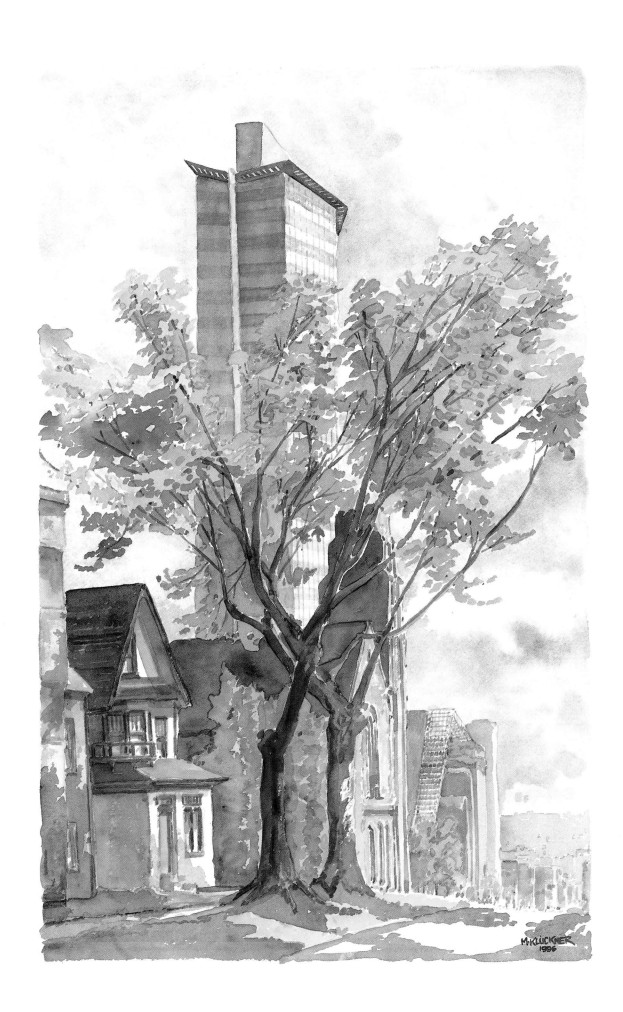

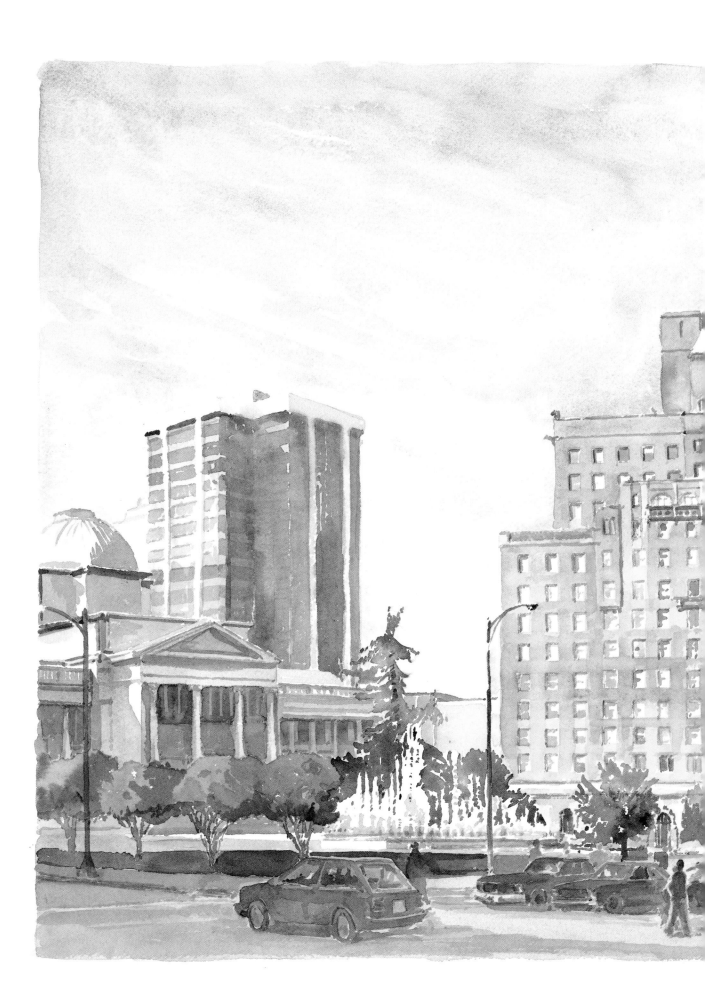

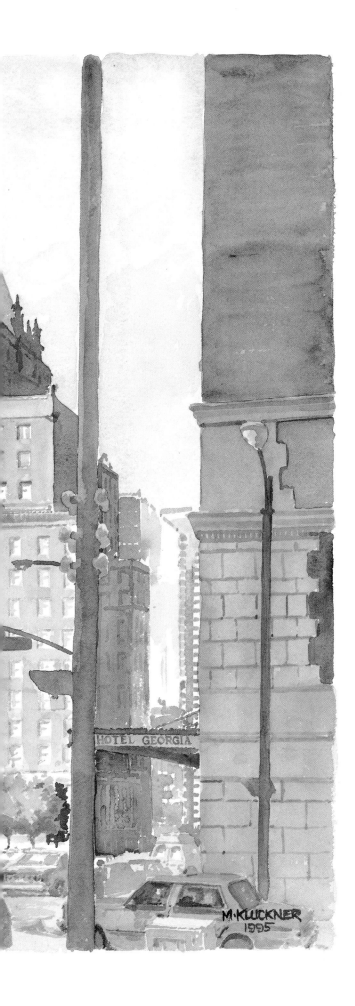

COURT HOUSE SQUARE

The morning sun illuminates the east facade of the Hotel Vancouver but is blocked by the city's first black tower, the Toronto Dominion Bank building on Georgia between Granville and Howe, which casts a cold, hard shadow northwesterly across Howe Street and up the facade of the Hotel Georgia. Before its demolition in 1949, an earlier Hotel Vancouver occupied the site of the bank building; it, with the new Hotel Vancouver, the Georgia, and the Devonshire Hotel, ringed Court House Square and comprised the city's hotel district, the only place (with the exception of the Sylvia Hotel on English Bay) where the respectable stayed and played while in Vancouver.

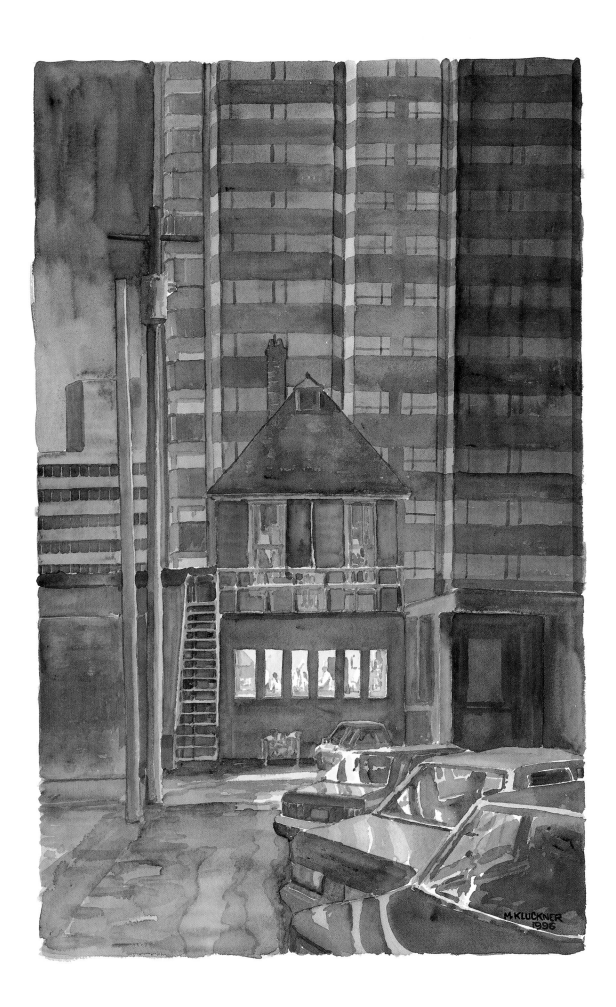

DOWNTOWN RESTAURANT

On Hamilton Street, only a couple of blocks from the
city's "Colosseum" library and expensive theatres, a house
converted into a restaurant survives amid the huge apart-
ment towers of the modern city. Although built for a
family of decidedly modest means, the little house dates
from a time when even small homes were constructed
with care and craftsmanship – just the sort of thing, a
century later, to provide the warm ambience demanded
by patrons of fine cuisine.

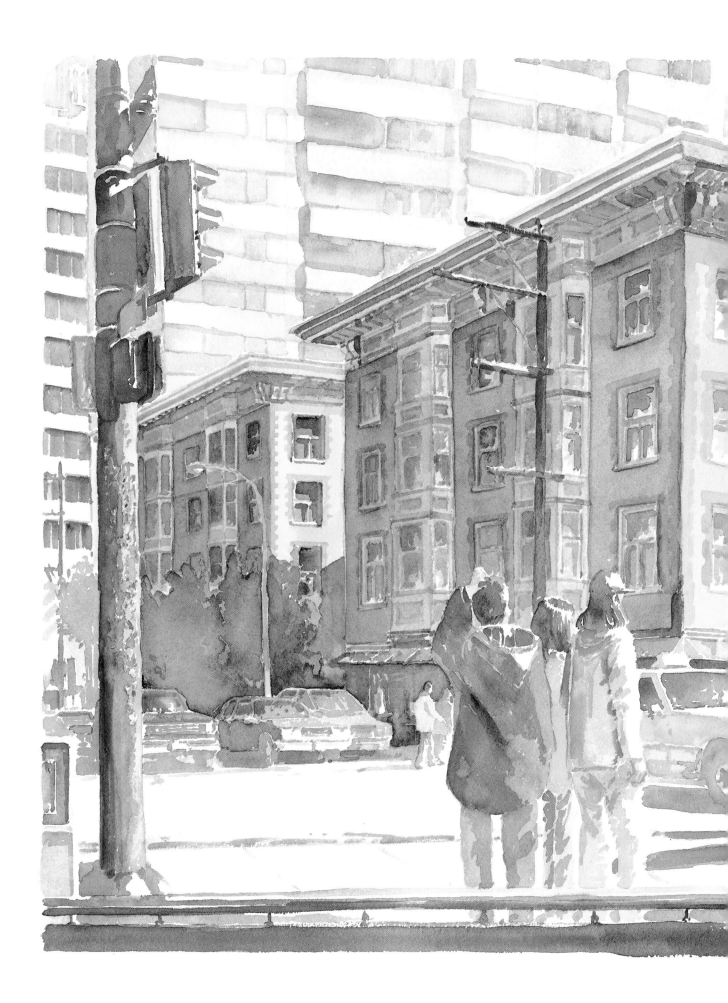

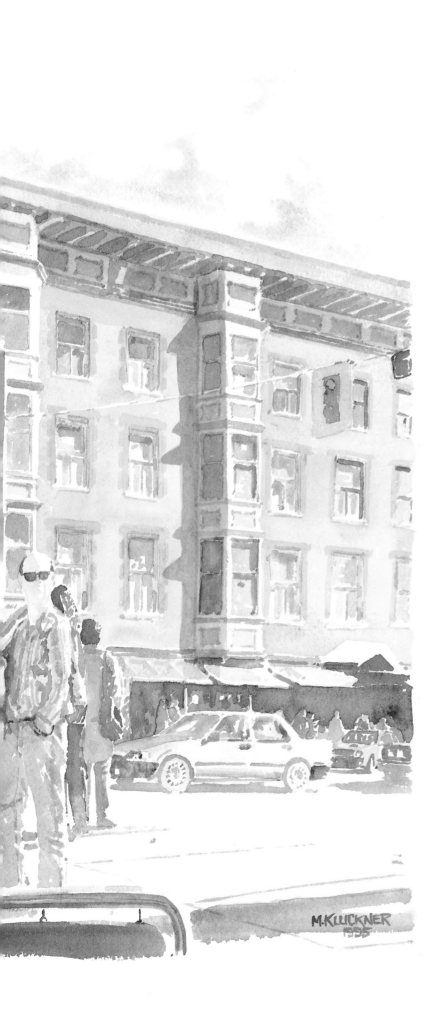

THE MANHATTAN

Now the mecca of the cappuccino culture, the Manhattan Apartments at Thurlow and Robson date from 1908, a time when the word *Manhattan* was a positive selling point. Robson had been a local shopping street since streetcar lines were laid in 1895, but by the time downtown Vancouver began to reinvent itself in the 1950s, it had become a low-rent strip, exactly the sort of place that attracts underfinanced entrepreneurs with good ideas. The result was a few blocks of European shops and restaurants, dubbed "Robsonstrasse," mainly single-story street frontages in the shadow of the redeveloping downtown, confirming the truism that most interesting things begin in old buildings. Meanwhile the act of demolishing old parts of cities and replacing them with blocks of towers had seen a new term enter the language – "Manhattanization," a process in Vancouver that threatened the Manhattan itself. In the late 1970s it was all but boarded up. Rescued by a longtime Kitsilano activist, Jacques Khouri, the restored and refurbished Manhattan has became the keystone of the new Robson Street. Across the lane to the north, the raucous Oil Can Harry's nightclub, paying rent on a piece of land slated for redevelopment, was not so lucky.

Big-City Streets

In spite of all the physical changes of the past generation, a Rip van Winkle could still recognize Vancouver. The new downtown buildings might disconcert him with their colour and size, and he might wonder about all the plazas and fountains after a couple of weeks of November rain, but he would find the lay of the land much as it always was. Seymour Street still runs down to the harbour, culminating in the dark red-and-cream facade of the old railway station, and other streets, like Burrard, in spite of the bulky towers popping up on the waterfront rail yards, still offer a glimpse of salt water and snowcapped mountains. Tourists carrying far too much luggage continue to arrive and leave on ocean liners, much as they did a century ago.

On the streets of the old downtown – Pender Street around Victory Square, Hastings Street extending past Woodward's to Main Street and beyond – most of the old buildings are still standing, and most of the new ones have fitted into the historic character of the area. The Sun Tower still looms above the rooftops and chimney pots, ever visible from Chinatown across the lowland at Abbott Street, which was once the unofficial border between white and Oriental Vancouver. In Victory Square, with the cheerful red roof of the Dominion Building looming above it, the Cenotaph is still well maintained, the martial flags crisp and bright in the morning sun.

But many of the surrounding buildings, especially on the blocks to the east along Hastings, have deteriorated, and many are boarded up like those in the tenderloins of American cities. A mixture of grime, cigarette butts, broken glass, and paper scraps speckles the edges of the street and eddies around the graffiti-covered doorways of the empty storefronts. The peculiar, unmistakable smell of big-city drains, which used to transport me instantly to Amsterdam or San Francisco, is now familiar here, too.

The "mean streets" quality of Hastings, east of Victory Square, is something new for Vancouver. Perhaps the longest running cliché in local history was the one about being able to walk anywhere and still feel safe; it is harder to do that

now along what was, until the late fifties, the workaday commercial hub of the city. Through the area every day came thousands of people, to the North Vancouver ferries at the foot of Columbia, the Union Steamship dock at the foot of Carrall, the Canadian National dock at the foot of Main, and the B.C. Electric interurban depot at Hastings and Carrall. Water Street was still lined with operating warehouses, many wholesaling groceries or industrial supplies and putting together orders for the coast's outports. Commercial salesmen came through the area, staying in hotels like the Europe on Maple Tree Square, as they had for 75 years; they ate "blue plate specials" and drank their coffee at the numerous cafés.

Woodward's Department Store on Hastings at Abbott was a magnet for people from all over the city; it was the down-to-earth department store, with work clothes, a pharmacy, a hardware department, and a food floor which, even in that roast-beef age, stocked imported foods from all over the world. Eaton's, laden with fashion and frippery, occupied a building now used by Simon Fraser University a few blocks to the west; it was a recently arrived upstart from the East, having bought out the venerable Spencer's chain only in 1948.

Although there was an edge of poverty and grit to East Hastings in the fifties, and it was known that prostitutes hung out here, heroin addicts strung out there, and the police force was riddled with corruption, no one would have called it a dangerous place for the casual passerby. As the hub of the working port, it was the holiday resort for loggers from upcoast, and on Hastings Street there were several loggers' employment agencies to push the men back on the coastal boats once they had spent their money and exhausted themselves in their pursuit of pleasure. Broken-down loggers with their meagre pensions stayed in the area, becoming resident in the old commercial hotels that no longer made the grade for professional travellers. When middle-class boys were about to take their first summer jobs – in the woods, on the highways, or in the mines – their mothers gave them money and sent them down to buy boots at Pierre Paris & Sons on Hastings near the Woodward's store. Hastings Street at that time felt very real – directly connected to a world of industry, opportunity, and failure – in a way that the modern Vancouver of suits and finance and tourism cannot equal.

The development of Gastown as a heritage tourist attraction and shopping area in the late sixties was not part of the "reality" of the Hastings Street world, having much more to do with the new, aesthetic lifestyles of neighbourhoods like Kitsilano than with Gastown's warehousing past. It was nevertheless an extraordinary experience for Vancouverites raised on stucco and the smooth finishes of downtown office buildings to come suddenly face-to-face with the textures and colours of masonry and aged wooden beams. As well, there were Indian cotton bedspreads, Japanese earthenware teacups without handles, bean-bag chairs with corduroy covers, incense and candles and bead curtains and black-light posters sold at emporiums like Trident and Cost Plus and Pier One – warehouses of sandblasted brick and sanded fir floors, Ikeas with a past. Was there a basement suite or garret in Kitsilano or the Fairview Slopes not furnished by these places?

Gastown came to be rejuvenated because its buildings were cheap; they were cheap because the area was all but abandoned. In the fifties, the popularity and

size of the semitrailer pushed wholesale grocers like Kelly-Douglas from narrow Water Street, in the building now called The Landing, out onto the wide-open stretches of Kingsway. At the same time Vancouver went crazy for the automobile: the new Second Narrows Bridge eliminated the North Shore car ferry; the provincial government went into the car-ferry business and pushed paved roads into nooks and crannies along the coast, while Union Steamship's coastal trade and the small logging camps it serviced gradually dried up; a new bridge to Richmond opened farmland to cul-de-sacs and commuting, and B.C. Electric dismantled its interurban railway system and built a new head office on the other side of downtown.

Chinatown, occupying Pender and Keefer Streets south of Hastings, had little connection with the white worlds of logging and industry, although since the twenties, Chinese farmers and entrepreneurs had all but controlled the produce business in the Lower Mainland. Like Hastings, the Chinatown streets had their gritty edge, but most Vancouverites visited Chinatown at night for the restaurants west of Main Street, when the grit retreated into the shadows and the rain-slicked streets were washed in red-and-green neon. The Marco Polo and the Bamboo Terrace had some of the best neon and served Cantonese food on white linen tablecloths in a fashion that made it acceptable to even the least adventurous white diner, while the Ho Ho and the Ho Inn farther west had more of the hurly-burly of commercial cafés.

Saturday mornings in the fifties constituted four hours of the standard 44-hour work week for white-collar types like my father, who laboured at an oak rolltop desk with an oak swivel chair in an office in the B.C. Electric building at Hastings and Carrall. His small wood-sashed window, grimy with the coal smoke from the nearby gasworks, looked out onto the roof of the Chinese Freemasons building, where Sun Yat-sen once stayed, and across the street at the small neon sign of the *Chinese Times* newspaper.

A professional musician in London before the war, he had returned to Canada following demobilization after 11 years away and migrated west to Vancouver with my mother, a lieutenant in the nursing corps. There was little work for musicians, so eventually he became a job analyst for the power utility and moved with his colleagues in 1957 to the new corporate skyscraper on the edge of the West End. His oak desk stayed at the old place, while his new office had a steel desk, with its chair riding on a curved acrylic pad atop the office carpet. Below his new window, which was a plate of glass almost to the floor, swept the tree-dotted carpet of the old West End – the two churches at Nelson and Burrard, old Dawson School and its gravel playing fields, St. Paul's Hospital all made of brick, and the rooftops and chimneys of a myriad wooden houses. In the distance were the construction cranes of the new West End high-rises.

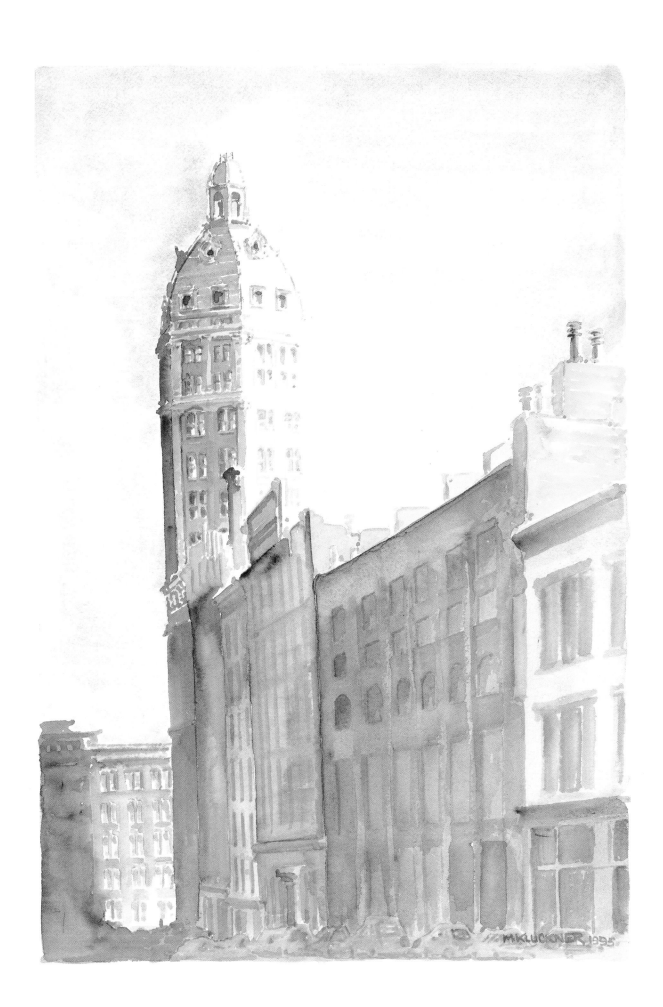

M.KLUCKNER 1995

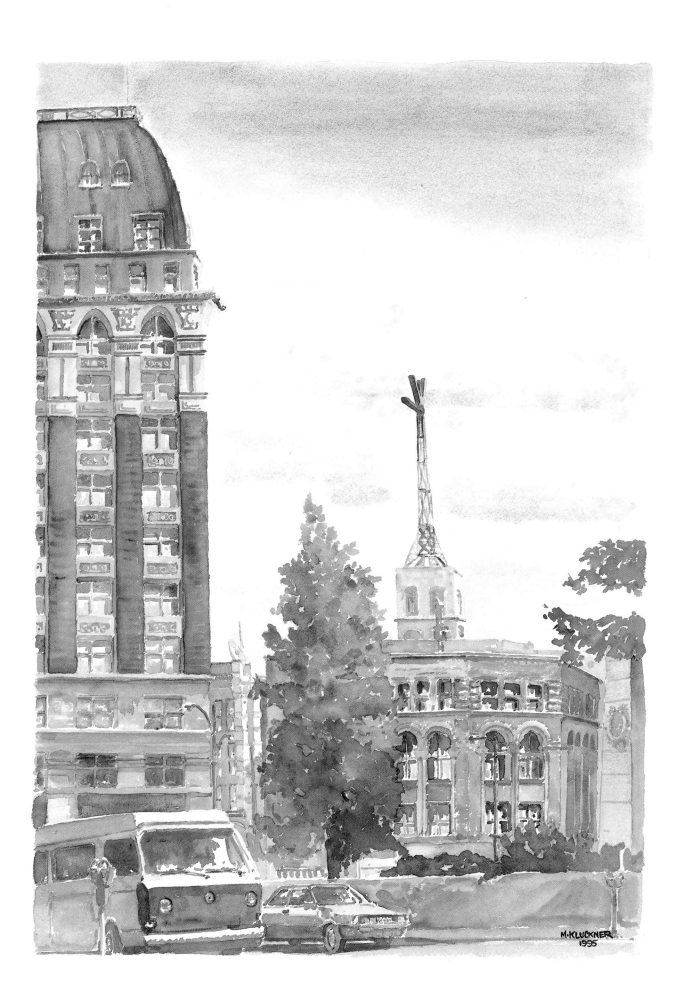

M·KLUCKNER
1995

VOLKSWAGEN VAN ON
HAMILTON STREET

Unlike the Sun Tower, the Dominion Building at
Hastings and Cambie has not been crowded in by
new development and still dominates its piece of
the sky, much as it did in the first decade of the
20th century when its size prompted the fire
department to purchase its first aerial ladder. Its
cheerful red visage gazes down on Victory Square,
the low-rise buildings of 19th-century Gastown, and
the boarded-up buildings on the blocks of Hastings
Street to the east. Atop a mini-Eiffel Tower at
Hastings and Abbott, the illuminated revolving *W*
of Woodward's Department Store was, in its day, a
beacon heralding good times in the Big Smoke, a
light as bright as the eyes of the loggers, flush with
cash, coming in on Union Steamship vessels from
the coast's outports to the wharf a few blocks away.

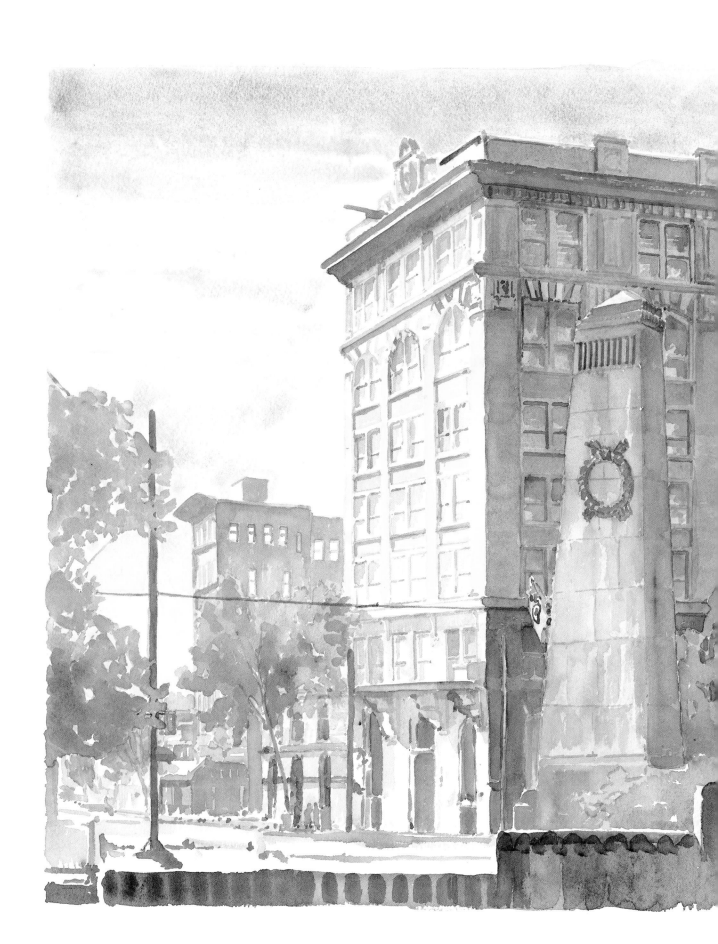

VICTORY SQUARE

The Cenotaph on Victory Square is an austere monument, dedicated in 1924 to those who fell in "the war to end all wars," and added to twice since. Its nonfigurative design has given it an undated, symbolic presence, unlike most other war memorials, two notable ones being the C P R -commissioned statue next to the company's former railway station on Cordova (now the terminal for SeaBus and the interurban train lines), and the bronze soldier on the lawn of Victoria's Parliament Buildings. The buildings surrounding the Cenotaph, including the Carter-Cotton Building shown here, and the Dominion Building, originally had as a neighbour the Vancouver Court House. After the opening of a new courthouse (now the Vancouver Art Gallery) on Georgia Street just before the First World War, the old one was demolished, creating the triangular open space that became Victory Square.

M·KLUCKNER
1995

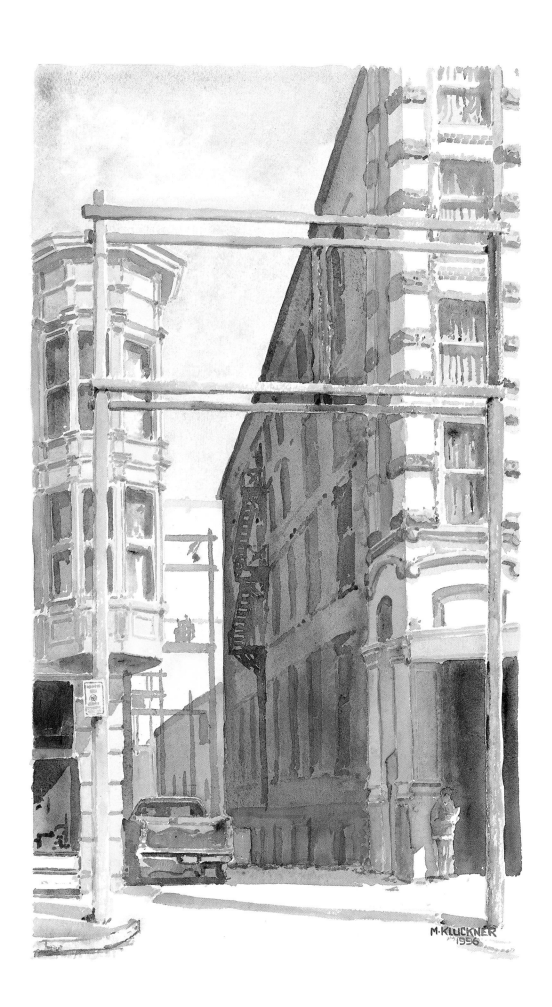

M·KLUCKNER
1996

BAY WINDOW ON CAMBIE

Vancouver is too new a city to have had the streets of
buildings with bay windows and hexagonal turrets char-
acteristic of 1870s and 1880s San Francisco neighbour-
hoods such as Haight-Ashbury. Those that were built
here have almost all been demolished. This window, the
best of the surviving ones, illuminates the two floors of
rooms above an Abyssinian take-out restaurant on
Cambie Street, just below Hastings across from the
Dominion Building. Built in 1888, it was the 81st build-
ing connected to the city's water system and is a simpler
structure than the 1896 hotel just across the lane. The
latter, in the innocent 1970s, achieved notoriety as the El
Cid, with clanking neo-Moorish carbuncles festooning
its main-floor entranceway and, in some rooms, naughty
closed-circuit videos and mirrored ceilings for visiting
impotentates.

NIAGARA HOTEL SIGN

Little remains of the gaudy advertising that was once
part of the visual richness of Vancouver; on the brick
sidewalls of some buildings, mainly in Yaletown and
along East Hastings, painted advertisements for ciga-
rettes, stomach remedies, and 25-cent rooms are now
only faintly visible. Buildings on the downtown com-
mercial streets, most notably Granville along Theatre
Row, Hastings east of Victory Square, and Pender
through Chinatown, once had magnificent signs, but
today only a few large ones, including the Niagara
Hotel's neon waterfall, have survived to brighten wet
winter nights. Curiously billboards survived the cleanup
and beautification mentality of the 1960s and 1970s,
although not in the numbers once seen in the city when
Ogden Nash's couplet – "indeed unless the billboards
fall, I'll never see a tree at all" – was almost appropriate.

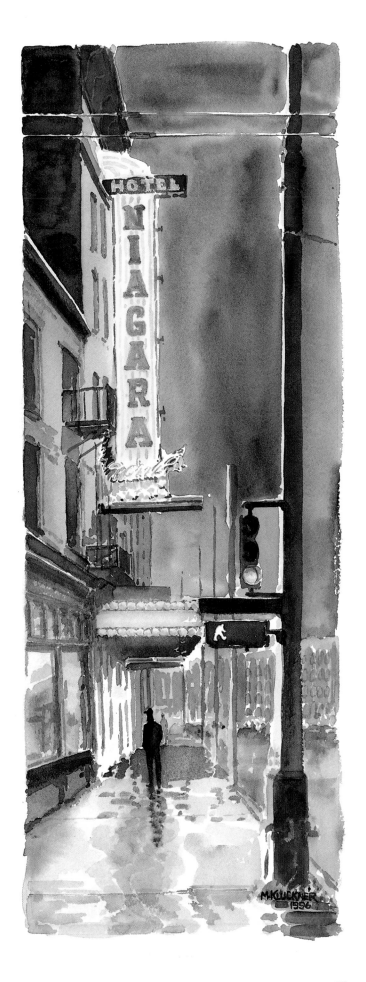

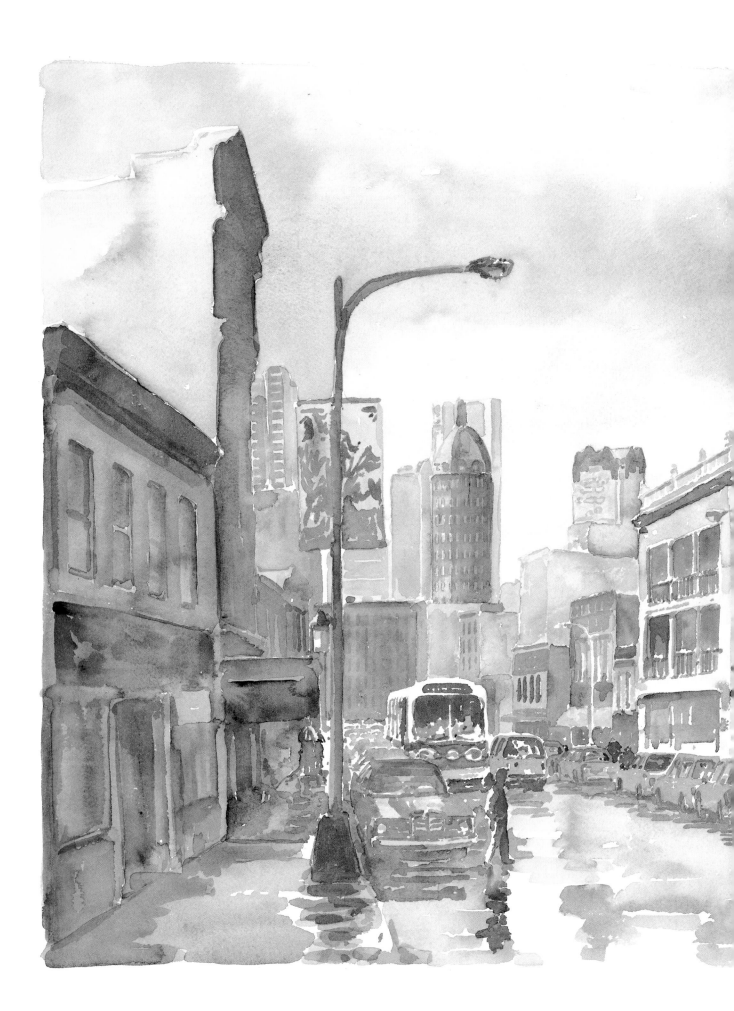

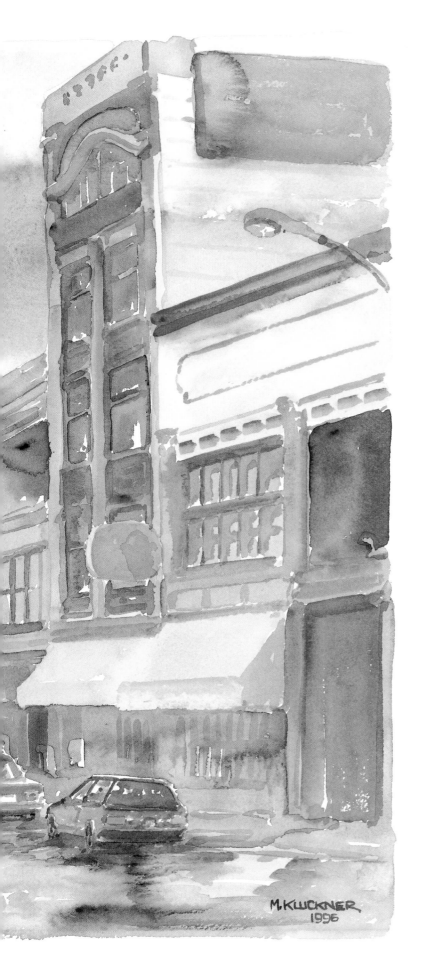

CHINATOWN

West of Main Street, Pender descends gently for a block toward what was, in Vancouver's early days, a swampy slough that at high tide allowed canoes and flat-bottomed skiffs passage between Burrard Inlet and False Creek. This low-lying land, with its promise of rising damp and mosquitoes, held no appeal for the European immigrants but offered affordability to Chinese immigrants, who during the 1880s and 1890s shared it with the little city's red-light district. The smallpox outbreak of 1892 was traced, perhaps by moralists rather than scientists, to a prostitute named Ella, who worked in a shack along this street. By the turn of the 20th century, Pender Street had become Chinatown's commercial strip, and a distinctive type of architecture – notable for the recessed balconies visible on several of the buildings – reflected the heritage of the area's business class. In the distance, on the rise of land known as the Beatty Street escarpment, the 1912 Sun Tower marked the eastern limit of the "European" business district. Today, from this viewpoint, in the same way that a thumb can hide the sun, the Sun Tower manages to appear as important as the huge towers of the modern downtown.

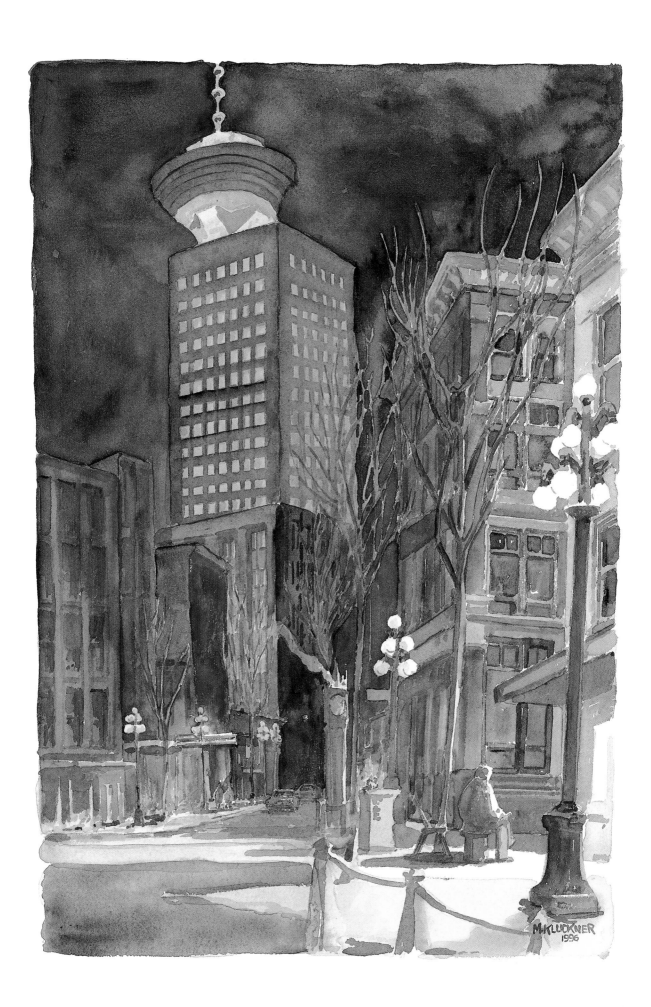

M.KLUCKNER
1996

GASTOWN

Water Street, which in colonial times was at the harbour's edge, came to be lined with solid brick warehouses once the shoreline was filled for rail yards at the end of the 19th century. Abandoned by their wholesale grocers and dry-goods mavens after the Second World War, the street's old warehouses found a new life in the 1960s as Gastown – named for the windbag and four-flusher "Gassy Jack" Deighton, whose saloon stood at the corner of Carrall and Water from 1867 until June 13, 1886, the date of the great fire. The resurrected Gastown of galleries, import emporiums, restaurants, and boutiques survived threats of freeways, demolitions, and redevelopment, brutal competition from new malls on uptown Georgia Street, and the province's Lord's Day Act (fought in the 1970s with the slogan, Historic Gastown – Historically Open on Sundays!) to become an established part of the downtown, and more than just a tourist destination. The painting looks west on Water Street, to the point where the road jogs to fit the colonial-era Gastown streets with the Canadian Pacific Railway's 1885 street survey. In sharp contrast to Gastown's historic buildings, and looking rather like a robot from *Star Wars,* the Harbour Centre tower with its revolving restaurant and observation deck is one of the city's landmarks from the 1970s.

Places to Walk

The intersection of Davie and Denman Streets, where Beach Avenue makes its graceful, tree-lined curve around Morton Park, is the symbolic heart of the English Bay beach community and one of the magical public spaces in Vancouver. In the history of the city it was the first great beach and summer watering place. Today it remains the great promenading place in a city where the citizenry seems too often to spend its time indoors in private rooms.

South of Davie all of the streets flow downhill toward the bay, the north-south ones like Jervis and Broughton offering views out to Point Grey, the east-west ones opening onto English Bay and forested Stanley Park, dark blue in the distance. On a triangular block between Burnaby and Harwood Streets, on the slope above the beach, is Alexandra Park (named for Edward VII's hapless queen), an oasis of mature trees in the centre of which is Vancouver's last surviving Edwardian-era bandstand. Another similar place in the Lower Mainland dating from that period is North Vancouver's Victoria Park, straddling Lonsdale Avenue with a view southward to the harbour; its radiating pathways were planted with rows of pink and white horse chestnuts in a pattern approximating the stripes on the Union Jack. The Brockton Point and Lost Lagoon areas of Stanley Park had much the same function for Vancouverites in the 19th century, although their layout is much less formal and follows the contours of the land; once those parts of the park were groomed they became immensely popular, at least in part because people could walk about and look at one another, rather than having to keep their eyes warily on the ground ahead of them for snags and puddles.

Bandstands and promenading parks date from the time when there was very little to do in Vancouver other than work and walk. There were, of course, no electronic media, and the outside world only entered the private home through the daily newspaper. The middle classes did not meet in cafés, as the custom was to dine and entertain at home; there were separate clubs for men

and women and saloons for the workers. People tended to stay put. Only a handful of the very rich travelled any distance for pleasure; interestingly, although they were so few in number, their large budgets created the CPR's memorable landmark hotels and transoceanic first-class steamships.

Today, after people travel to countries such as Italy and experience the way the citizenry promenades in the evenings and on weekends, they return to Vancouver and wonder why the same thing doesn't happen here. However, in the Edwardian days it *did* happen; people did promenade through Victoria Park and Alexandra Park and along English Bay at every available opportunity. On the weekends they gathered to listen to brass bands and touring vaudeville acts playing in striped tents on the edge of the sand. In the little Vancouver of 1910, with a population of about 100,000, vast throngs gathered at English Bay and Stanley Park in pleasant weather, the sort of crowds that today only show up for spectacles such as the Symphony of Fire fireworks extravaganza or the Molson Indy auto race. On summer days thousands swam in English Bay, and in the evenings families walked out onto the pier that jutted into the water near the foot of Gilford Street. Now only the carol ships on December evenings, bedecked with strings of coloured lights, re-create something of the same spirit as they motor slowly past the tired and huddled masses on the beaches of Kitsilano and the West End, and on the shores of North and West Vancouver.

Like every other desirable piece of Vancouver, the English Bay waterfront has seen its share of change in the past 30 years. In the 1950s the landmarks were the Englesea Lodge, on the waterside of Beach Avenue at the entrance to Stanley Park, and the Sylvia Hotel, built in 1912 as an apartment block but converted during the thirties into a hotel that became known for its "Dine in the Sky" dining room – for Vancouver insiders of the postwar period, a more desirable haunt for an intimate evening than the busy downtown hotels. At Davie and Denman stood the once fashionable Simpson Apartments, a four-story building with patterned-brick walls, deep light wells, and bay windows. The other buildings fronting the beach, across the street from the bathhouse and changing rooms, were single-story shopfronts with deep canvas awnings (a couple were hammered-together additions on the fronts of old houses). Racks of postcards cluttered the edges of the sidewalk. With the Tetley's Tea sign atop one building, English Bay could have passed for Blackpool.

Gradually the old houses along the beach came down, including the one near the park where Niklaus, a hairdresser with an Eastern European accent and a great ability to create bubble-cut perms, plied his trade to women like my mother. We were expected to accompany her to the hairdresser but were allowed to roam the streets and beach for an hour until she emerged, groomed.

Low-rise Moderne apartment buildings with aluminum-framed windows set in horizontal bands took the places of many of the houses. Then came the high-rises, most notably Ocean Towers on Morton Avenue – a great yellow slab of a building whose plate-glass windows looked directly into the setting sun; it was and is curious, being a one-sided building, with corridors on the north side that face away from the beach. The English Bay Café, for years a homey fish-and-chip shop with a Coca-Cola sign and stools along a Formica counter, lasted until the 1970s and was then converted into a full-scale restaurant. The

last survivor of the shabby, postwar English Bay was the Surf Motel, redolent of cooking smells and mouldy carpets, sandwiched between Ocean Towers and the Sylvia Hotel.

From the surrounding towers on summer evenings comes a great cross section of contemporary Vancouver: the elderly moving slowly with canes; punks in black leather, piercings, and Dayton boots lurking in dangerous little clusters; lovers of all genders and ages parading arm in arm; tourists festooned with cameras and camcorders whirring and snapping. Old men with exceptionally tired, sun-ravaged skin put on their singlets, pick up their towels, and amble back toward the city. As the beach and paths fill, the popcorn vendors with their decorative carts and the ice-cream salesmen – some riding push tricycles with the freezer set between the two front wheels, others crawling along Beach Avenue in trucks – do a roaring trade. Jugglers and other exhibitionists, who could be auditioning for parts in a Fellini film, compete in vain with the spectacle of the sun descending into the sea.

As evening commences, the colours of English Bay's amphitheatre begin to change and there is an almost audible hush over the waterfront as the sun's rays tinge the clouds first with orange, then with purple; the ring of blue mountains changes first to a dusky pink, then gradually to shades of indigo. The shadows quickly gather under the trees and along the paths, but the sunlight, invisible now to the promenaders, reflects brightly from the upper windows of the buildings along Beach Avenue and briefly bathes the streets below in a weird golden light. Then, suddenly, the day is gone, and those who haven't had enough retire to the bar in the Sylvia.

SYLVIA HOTEL FROM EUGENIA PLACE

Seagulls and residents of the upper floors of Eugenia Place have a view past the ivy-covered walls of the Sylvia Hotel and along the curve of Beach Avenue, past Morton Park and Alexandra Park to the point where English Bay narrows into the mouth of False Creek and Beach Avenue swings sharply eastward to pass along Sunset Beach and False Creek's north shore. Vanier Park, the Planetarium, and the Kitsilano hillside occupy the distant shore. The tall apartment building with the blue trim, touted at its 1963 completion as the tallest building in western Canada, was designed by an architect with the evocative name of Kaffka and financed by Tom Campbell, who was soon to become mayor.

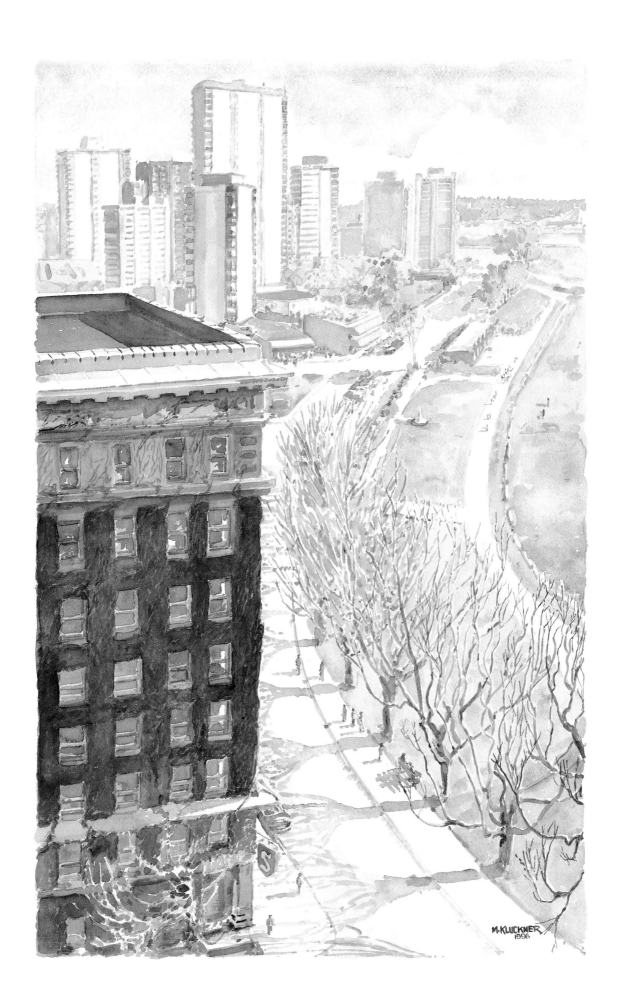

M·KLUCKNER
1996

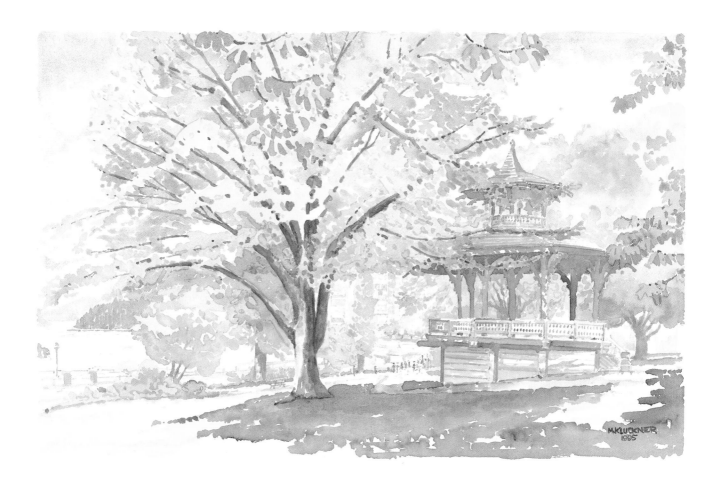

BANDSTAND

In Alexandra Park, like Morton Park a triangle with curving Beach Avenue as its hypotenuse, the last of Vancouver's Edwardian bandstands shares a dappled, grassy lawn with a beech tree, some horse chestnuts, and a huge, spreading red oak. In an era when only the wealthy could afford to purchase recorded music on wax cylinders, and West End ladies formed small orchestras to amuse themselves, the populace promenaded and was entertained by brass bands playing the martial, patriotic marches and hymns popular on the eve of the Great War. In the distance Stanley Park's wooded peninsula completes the curve of sand around English Bay.

BEACH HOUSE

Although much of Stanley Park remains in its natural state, encircled by a seawall from which the views are outward toward the harbour and the mountains, there are parts of it that were cleared and planted generations ago to create a true city park. One such area, near the English Bay entrance to the park and adjoining the West End's apartment buildings, features tennis courts, a lawn bowling green, a pitch-and-putt golf course, and the Sports Pavilion, a 1930 building usually known as the Beach House for the restaurant therein. Much of this cleared area was grazed by elk in the park's early years, just as a herd of bison used to patronize the meadow above the yacht club in Coal Harbour – part of the informal zoo of the time. Lawn bowling began in 1919, with golf and tennis facilities established early in the 1930s.

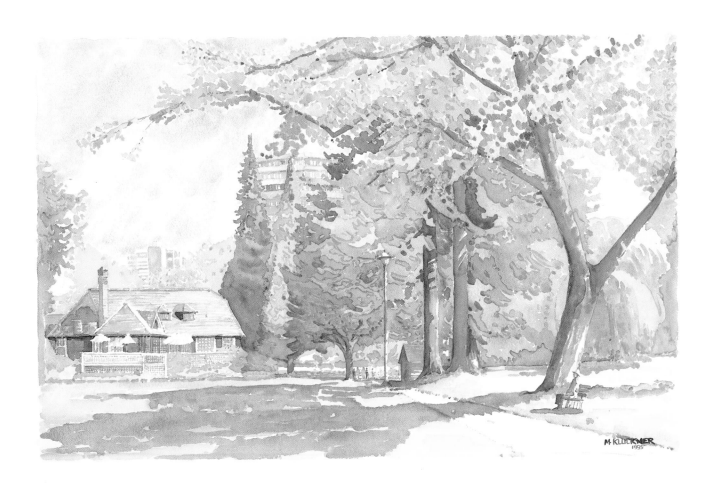

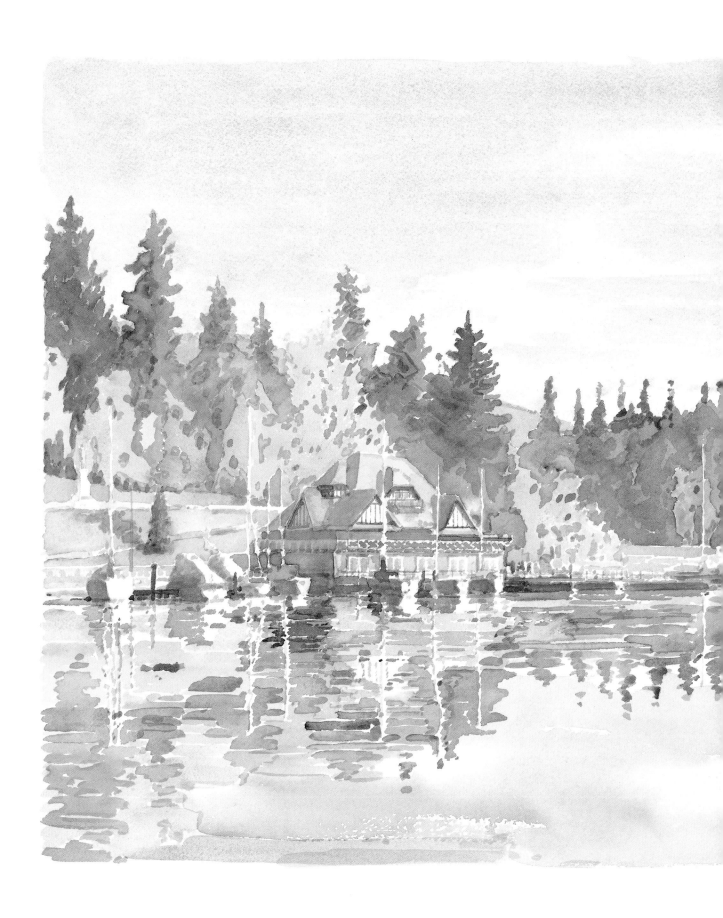

M.KLUCKNER
1996

ROWING CLUB

As if a Constable millpond, Coal Harbour ends in a quiet backwater where the West End meets Stanley Park. The Vancouver Rowing Club's headquarters, built on pilings in 1911 when the club moved its digs from the foot of Thurlow Street, rests against the bank between the Robert Burns statue on the park road and the hulls and masts of the Royal Vancouver Yacht Club's fleet. Long a favourite of rowers, Coal Harbour was also the site of the first local experiments with "hydro-aeroplanes," the first demonstration by a visiting aviator taking place in 1914. Three years later a seaplane designed and manufactured in the Hoffar Brothers boat-building shed at the foot of Bidwell was making successful flights, and February 1919 saw the arrival of William Boeing, following the first flight between Seattle and Vancouver. Until the 1960s the Coal Harbour shoreline was the centre of the region's small-boat industry, and West Georgia was lined with low wooden buildings, with wharves and marine railways extending behind them. In the 1930s and 1940s, along the shoreline where I sat while painting, more than 50 houseboats squatted, homes for about 200 people who had jobs in the factories along the shore, including a small Boeing assembly plant at the foot of Denman Street. However, late in the 1930s the Park Board and Town Planning Commission suggested that Coal Harbour should be rid of "the heterogeneous mass of floats and small craft that clutter up the shoreline." In 1956 a group of investors announced its plans to erect a "garden court" hotel with a marina and seaplane dock – the Bayshore – on the site of an abandoned sawmill, a decision they felt would make Georgia Street the equivalent of Wilshire Boulevard in Los Angeles. When the hotel opened, the head of the management group was Del Webb, who was the owner of the New York Yankees at the time. In 1962 an even more lavish proposal by this group to build a gold-plated apartment and marina project between the Bayshore and the park entrance forced the remnants of the marine industry and the houseboaters away, but years later, when a start on the project appeared imminent, an aroused populace declared the shoreline a "People's Park" and even occupied it during the summer of 1970. Today the Coal Harbour shoreline is once again cluttered by "a heterogeneous mass of floats and small craft." But this time the owners are a more politically empowered group than the one kicked out a generation ago.

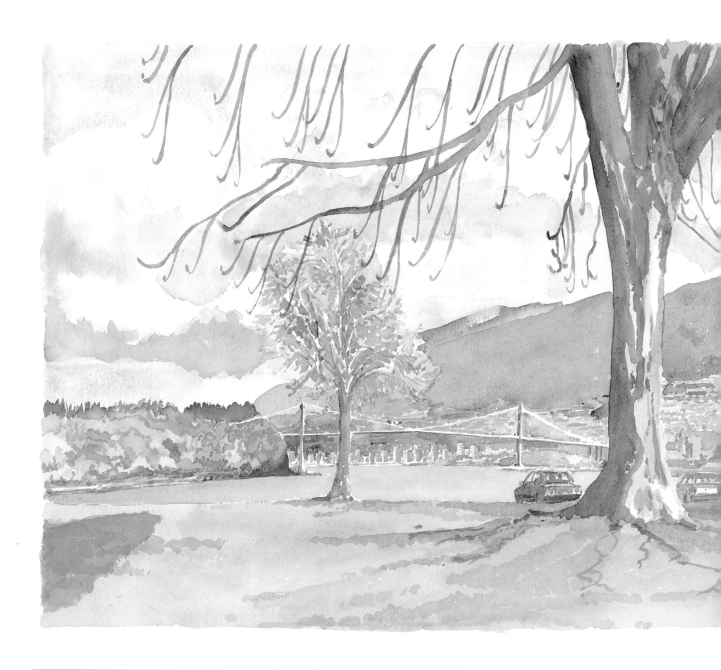

LIONS GATE BRIDGE

From Brockton Point in Stanley Park there is a panoramic view of the working harbour: freighters moving to and from the container terminals, bulk carriers loading cargoes of grain and sulphur, seaplanes buzzing in and out, the SeaBus plying its route between the downtown waterfront and the foot of Lonsdale Avenue in North Vancouver, sturdy tugs puffing and pushing, and the occasional sleek cruise ship easing past the Brockton Point lighthouse on its way to the dock at Canada Place. In the distance, spanning the inlet's first narrows, is Vancouver's answer to San Francisco's Golden Gate Bridge, the Lions Gate Bridge. Like its American cousin, it was a project of the Depression years of the 1930s but was realized in a much more tentative way, reflecting the "nowhere" status Vancouver had for the financiers of the period, most of whom lived elsewhere. Built by Guinness interests to provide access to its British Properties subdivision on the West Vancouver mountainside, the bridge (unlike Golden Gate) did not connect Vancouver with anything else of value. Moreover, few people had cars: about one for every seven people, compared with one for every three in Seattle at that time. The promoters had trouble raising money and ended up creating a piece of sculpture that brilliantly defined the entry into Vancouver for shipboard passengers while, almost as an afterthought, carrying two lanes of automobiles. There was so little traffic to the North Shore in the 1940s that people often parked their cars midspan and leisurely took in the view before driving north, where they paid a toll before arriving at the stop sign where the bridge ramp hit Marine Drive. As the North Shore developed, the provincial government squeezed three tight lanes onto the span and built the cloverleaf at the north end, a situation that has endured for more than 40 years. The bridge's eventual replacement will probably be a tunnel, leaving open the question of whether the former is worth maintaining as a pedestrian and bicycle crossing and, not insignificantly, as a symbol of the city on the threshold of modern times.

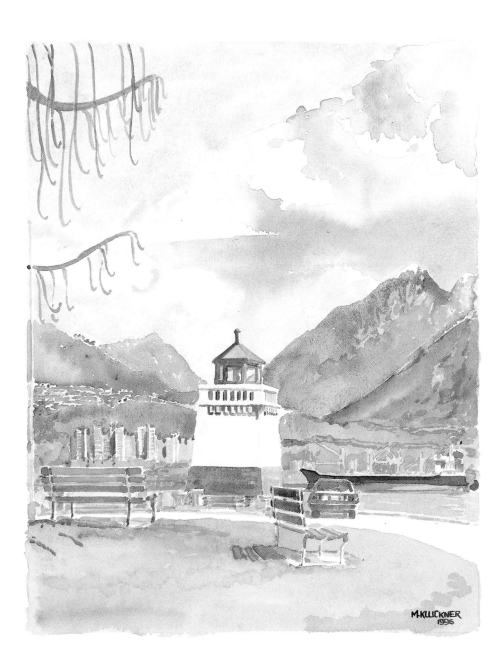

BROCKTON POINT LIGHTHOUSE

There has been a lighthouse at Brockton Point since
1890, marking the last peninsula of Stanley Park shelter-
ing Coal Harbour from Burrard Inlet. In the early years
the lighthouse keeper was a man named William Jones
who, as part of his duties, fired a time signal at nine in
the evening so that ships' masters could reset their
chronometers. Initially the signal was the detonation of
a stick of dynamite, replaced in 1894 (according to one
story) by a cannon (in other stories, the cannon was
first used as a start-stop signal for gillnet fishermen).
The ordnance, facing into Coal Harbour, was cast in
England in 1816 and helped guard Esquimalt harbour
during the British-American border dispute of the 1850s
known as the Pig War. It still fires at nine each evening
– a peal of thunder rumbling through downtown's glass
canyons and echoing around the harbour.

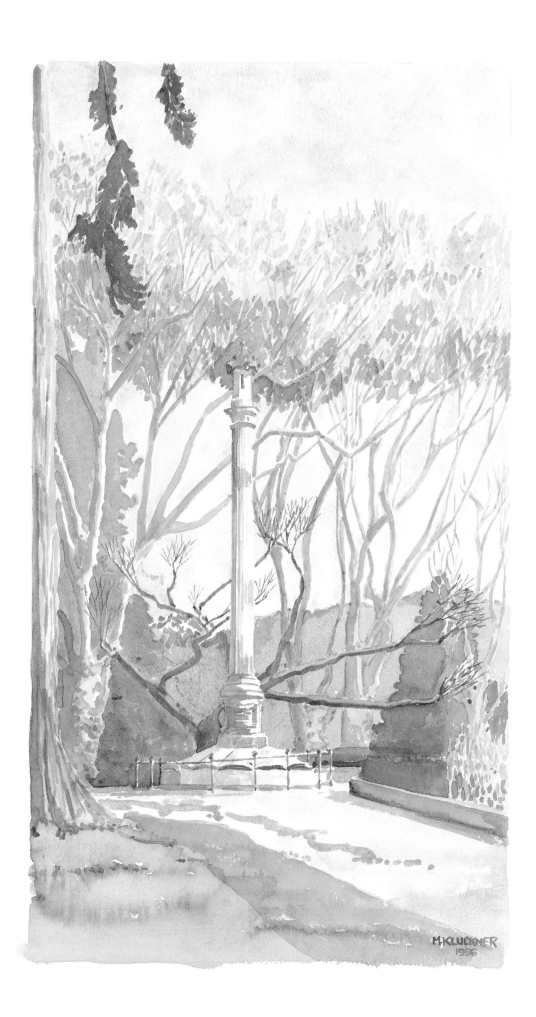

M. KLUCKNER
1996

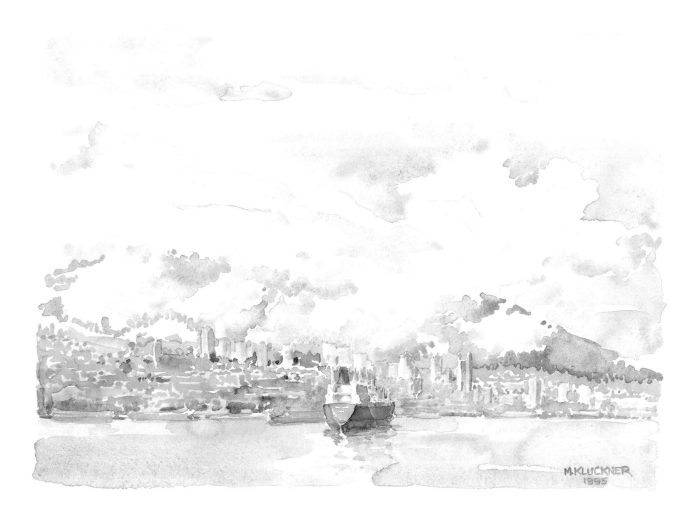

CLOUDS OVER NORTH VANCOUVER

Once the low-pressure fronts pass over, the rain stops in the city and the sky lifts – sometimes clearing suddenly and dramatically – but often the clouds continue to hang in shreds and rags in the damp, unstable air over North Vancouver.

JAPANESE WAR MEMORIAL

No piece of sculpture could be more evocative of the fickleness of friendships and alliances than the Japanese War Memorial in Stanley Park. Although Japan had been an ally of England, and thus of Canada, in the early years of the 20th century, and many Japanese Canadians (who could vote neither in British Columbia nor in Canada) served in the Canadian Expeditionary Force during the First World War, this memorial to their sacrifices was not erected by the Japanese Association until 1932, by which time there was little memory locally for their heroism. Instead, the general public had been treated throughout the 1920s to increasingly sharp criticism of Japanese Canadians for their "peaceful penetration" of white institutions and industries, and had followed for a year the news of Imperial Japan's brutal military takeover of Manchuria. In the wake of the attack on Pearl Harbor, 10 years after the war memorial was dedicated, *all* people of Japanese ancestry, regardless of citizenship, were rounded up and shipped away from the coast (as also happened in the western United States).

ON THE BEACH

Spanish Banks, Locarno, Jericho, Kitsilano: exotic names for the beaches of a little Protestant mill town on the edge of the saltchuck. Here windsurfers, dog walkers, novel readers, and sunbathers use the foreshore and the chilly English Bay water to find some solitude on the edge of the frenetic city.

We used to go to the beach a lot in the mid-sixties, usually to Jericho. My friend Rob drove all of us down Alma Street, negotiating the cobbles left after the streetcar tracks were removed, in his parents' huge Buick Wildcat (vintage 1964, I think), dubbed "The Pink Pig," and we settled into the sand while the sea breeze blew steadily and the tinny transistor sound of LG or CFUN danced merrily atop it. Top Forty radio. Our cluster of half a dozen bodies was repeated here and there across the sand, as was the transistor sound – a cheerful chatter from dozens of tiny tinny speakers. That, at least, was part of the difference then – portable radios could not produce the boom of modern ones.

Vancouver's beach culture has evolved steadily over the decades, ever since trails and, in the 1890s, streetcars, allowed families access to English Bay and relief from hot, airless sleeping rooms and summer meals cooked on wood-stoves in small kitchens at the back of tall houses on narrow lots. By the turn of the century, city people – that is, those who lived in the little port town clustered on Vancouver's downtown peninsula – had discovered that beaches such as Kitsilano and Spanish Banks were good places to spend a summer vacation. It was, after all, difficult and expensive to go anywhere else.

Photographs from the years dating around 1905 show a wall of white canvas tents along the bay at Kitsilano, when it was still called Greer's Beach. After the First World War, campers at Spanish Banks shared the beach with squatters. One of these – James Quiney, *the* real-estate agent in northwest Kitsilano before the war – eked out a meagre supplement to his wartime disability pension by selling hot water to the campers. In the twenties and thirties, thanks to a direct streetcar from downtown, huge crowds flocked in the direction of the

Union Jack flying over Kitsilano's bathhouse to sunbathe and swim; the news-papers estimated that 80,000 people used the beach regularly, far more than the number who used the West End beaches, and certainly far more than the number of people who use it now. The Oriental beach – unofficially segregated by the unofficial rules of the time – was the untended, unimproved piece of shoreline on the former Kitsilano Indian Reserve, now the Vancouver Museum and the H. R. MacMillan Planetarium site. At that time it was wedged between Kitsilano Beach proper and the "Bennettville" squatters community at the south end of Burrard Bridge.

I had a great-aunt and great-uncle who, in the 1880s, set off in a wagon from the railhead somewhere in Manitoba and headed on little more than a compass bearing to a homestead on the fabled bald prairie. For 30 years they worked their plot, and when they were unable to continue, they sold up and moved to Vancouver – which, even in the good times of the twenties, was rea-sonably cheap – and took rooms in an old house near the beach. According to family legend, on any day when it was not actually frosty or raining, they packed a lunch and carried it and their blanket to the beach, where they sat, stared out at English Bay and the mountains, said little, ate, and then napped before making their way home. It was free and they were worn out.

In the thirties my grandparents had a cottage – a small bungalow with a hipped roof and a single dormer – on Cypress Street between Seventh and Eighth Avenues, a house still standing amid the parking lots and apartment buildings of modern Kitsilano. With a promised pension of $35 a month from the Canada Vinegar Works and failing eyesight due to cataracts, grandfather had retired and moved west from Winnipeg. Their savings handily bought the house for $425. For a time they went to the beach every day, too. Sometimes grandfather walked from Kitsilano to Stanley Park and back, carrying his binoculars so he could read the street signs. There were lots of other things to do, but most of them cost money.

Beach pictures from the twenties and thirties show women in flower-print cotton frocks sitting on the sand, their men in jackets and ties, or ties at least, fully shod beside them. Only the children, with their buckets and shorts and sexless little bodies, were free to feel the salt breeze and the salt water and the sharpness of the sand on their skins. The parasols of the turn of the century, when a suntan implied enforced outdoor labour and low social status, had by those years been relegated to attics and closets; the women squinted into the sun and brushed back wisps of hair that the breeze had dislodged from their carefully pinned buns. Men wore hats.

The march toward hedonism on the Vancouver beaches was a slow one. Early in the century the Vancouver Moral Association warned of the dangers of one-piece bathing suits for men. All Park Board beach houses rented swimsuits and towels, the black wool type with stockings being the most popular for women until the 1940s, when women broke free enough to "shiver in cotton," as a newspaper report put it. After men were arrested for appearing topless on city beaches in the early 1930s, the Park Board responded to the winds of change and passed rules prohibiting only those suits "not of sufficient height to cover the navel." Both women's and men's suits had a small skirt at the front. However, by the 1970s, when sexually transmitted diseases were usually curable

and the ozone layer was intact, the skirts and most other evidence of inhibition had disappeared altogether.

Through all the growth in population and changes of morals there have remained very private stretches of beach along English Bay. The public nudists of the 1960s invaded Wreck Beach, located below the Point Grey headland and the University of British Columbia. A piece of wild seashore long popular with the city's private nudists, Wreck Beach soon turned into something of a circus, with margarita salesmen cooling the inner person and boats loaded with binocular-toting oglers cruising by just offshore.

With today's wounded sky, and skin cancer lurking on the edges of each sunny day, fewer people sunbathe in high summer. Perhaps the beaches are now at their best in the spring and the fall. Although the distant Howe Sound mountains hold on to their snow for some months yet, early April can be warm and bright, a harbinger of the hot summer to come. Only a handful of sunseekers go to the beach and have the vast stillness of the sand and wind and sky to themselves.

Logs are a part of every Vancouver beach experience; in spring the Park Board rakes the sand for cigarette butts, other garbage, and excreta, then rearranges its official logs into lines along the shore. Often during a spring day there is a westerly breeze blowing, a wind sound that eliminates the surrounding noises of traffic, dogs, and children, so that the sunlight and sand become a world of great solitude, completely cut off from the nearby city.

The undeveloped piece of natural beach along the Kitsilano shoreline, between Kits Beach proper and Jericho, still has its quiet spots between the rocks and random drift logs where people do as they please in relative privacy. On some summer evenings, when the smelt are running, Greek fishermen still cast their nets along the shore there. A patch of wild mint thrives in the scrub near the picturesque little park at the foot of Trafalgar Street. Each high tide brings in interesting shells and weird ropes of kelp. Much more than the groomed sand beaches elsewhere along English Bay, this undeveloped piece of shoreline is emblematic of a new beach culture in the city.

Since the late 1920s some public figures have advocated creating an "Ocean Boulevard" along Point Grey Road by demolishing the expensive houses that shield the natural beach from city traffic and noise. A number of little "parklets," a city lot or two wide, have been created at great expense to offer peekaboo views of English Bay to passing motorists, and to provide a place to deposit huge quantities of dog feces. The more the bank above is groomed, goes the argument, the more likely it is that the beach below will be tidied. As the years have gone by, the public has become increasingly united in the opinion that the shoreline there should remain as natural as possible, with the houses above providing a buffer.

It is on that natural strip of Kitsilano Beach where one of Vancouver's great summer rituals is best enjoyed. In high summer the sun sets after nine o'clock over the saddle on Bowen Island rather than plummeting into the gulf as it does earlier, and later, in the season. Although the beaches have usually emptied for dinner, as the sun begins its descent they fill again, and people find quiet spots to sit in the sand or among the rocks and, with little conversation or exclamation, quietly watch the sunset.

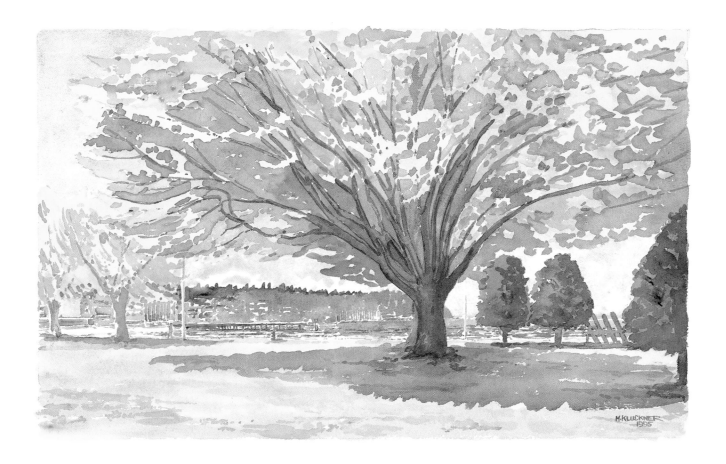

WINDY DAY AT KITSILANO BEACH

The occasional windstorm that hits Vancouver usually occurs in the autumn and has a dramatic effect on the colour of the ocean, changing it from the pale greys and blues of calm days into a rich turquoise flecked with whitecaps. Few cities are as windless as Vancouver usually is: flowers grow tall and spindly in shady gardens and get blown over by summer breezes, a far cry from the situation in Victoria or the Fraser Valley; a woman who grew up in Agassiz, at the eastern end of the Fraser Valley, commented that she didn't know that rain could fall vertically until she moved to the city. The view in the watercolour looks west from Kitsilano Beach, past the old city wharf now used by the Kitsilano Yacht Club, toward the Point Grey headland.

FOLLOWING PAGE

LOW TIDE AT KITS BEACH

Kitsilano Beach was cleared and groomed in the years just before the First World War, then coated with sand scoured from the bottom of False Creek, which was at the time being deepened to improve shipping access to the industries marshalled along its shore. In these days of diminished ozone and enhanced recreational options, only a few land-based creatures – mainly small children and dogs – brave English Bay's chilly waters. Most summertime beach addicts now sunbathe with discretion; they arrange their gear against a favourite log, cover themselves with a double-digit blocker, put a favourite tape in their Walkman, and lose themselves in the sea breeze and the view of the harbour with its anchored freighters, the West End towers and Stanley Park, and the North Shore mountains.

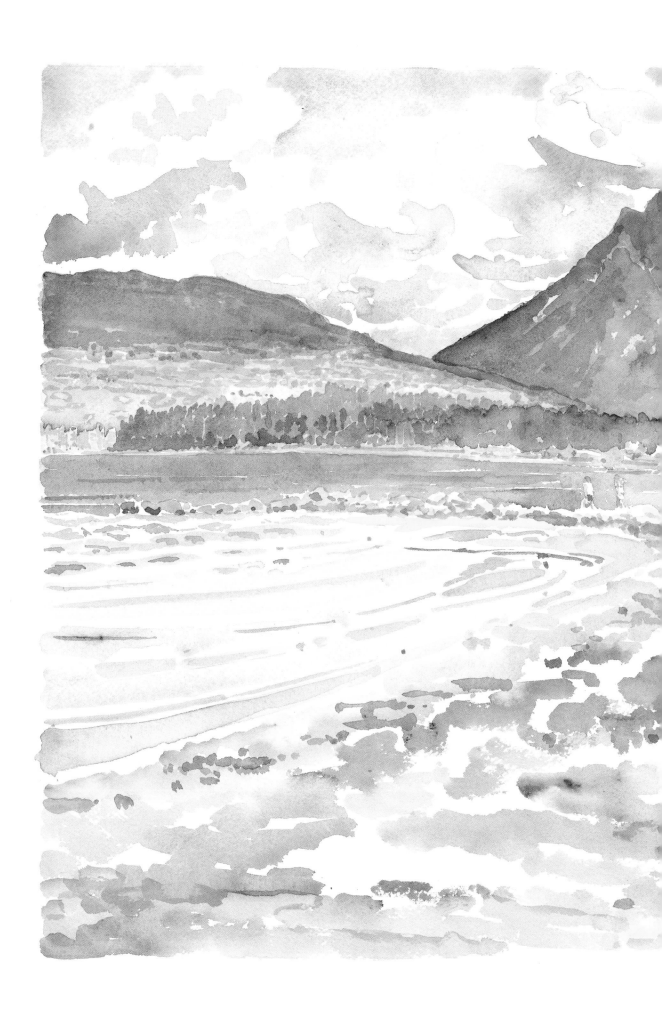

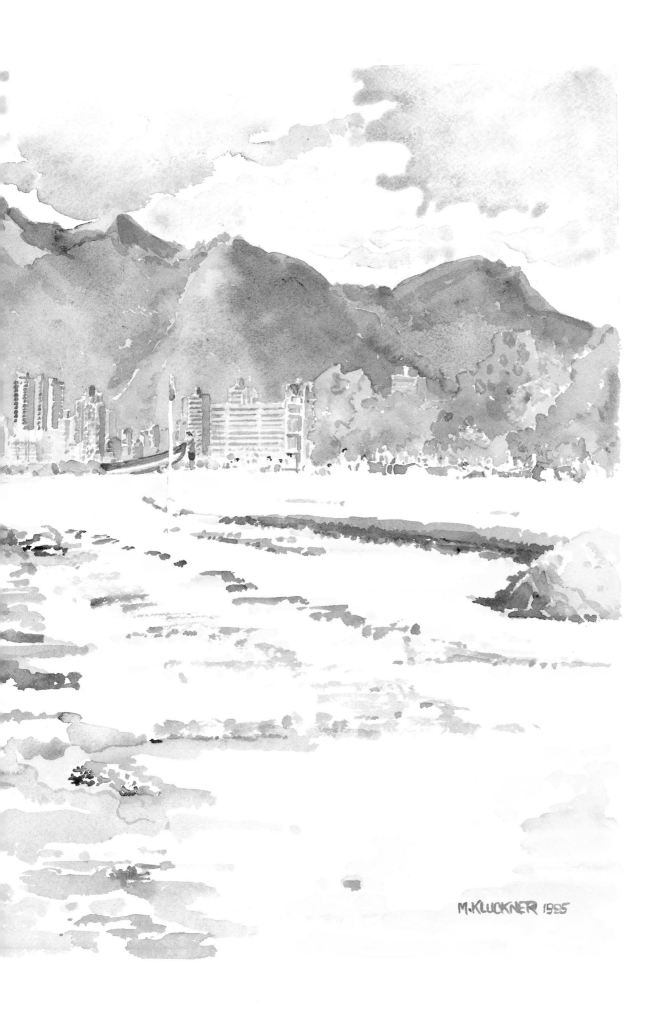

M. KLUCKNER 1995

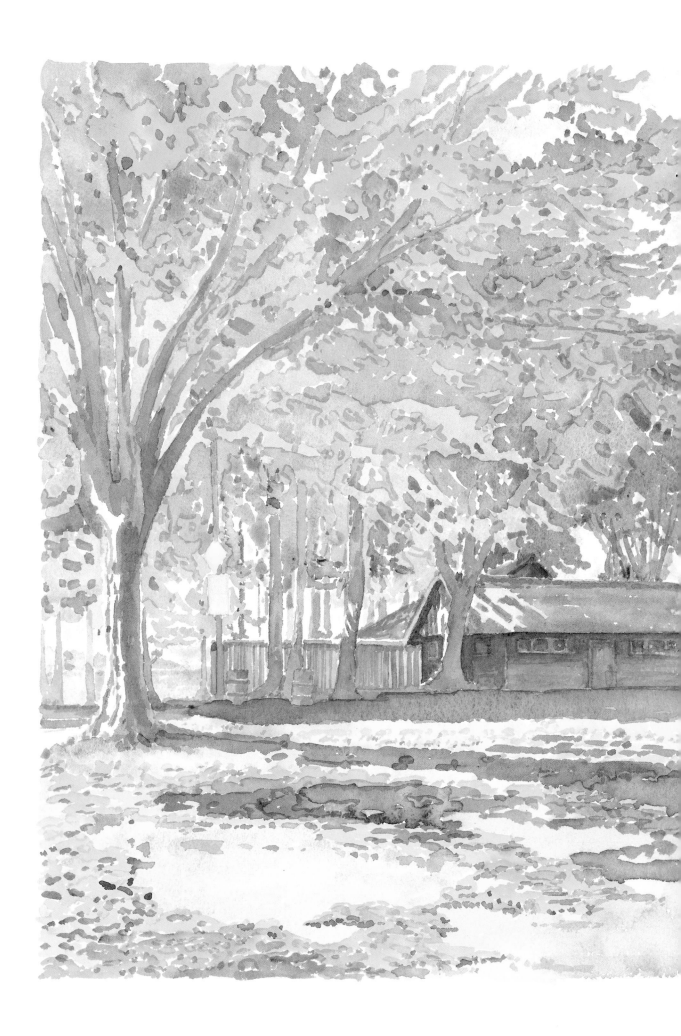

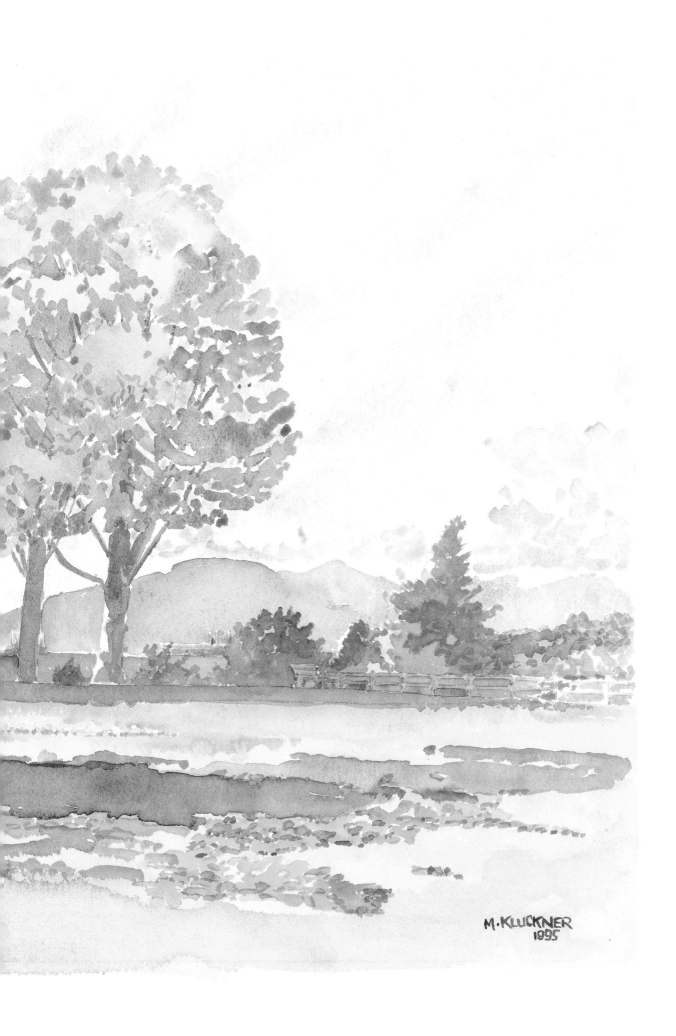

CARETAKERS' HOUSE AT HADDON PARK

At the tip of Kitsilano Point, between the museums complex on the old Indian Reservation and Kitsilano Beach, there is a strip of park and foreshore named for a jeweller, Harvey Haddon, who donated the land to the city in 1931. For much of the year it is a dogwalkers' and Frisbee throwers' place; families picnic in the shade of the maples and at tables beneath the trees in the distance; and joggers churn and puff along the pathway at the edge of the bluff and descend the grassy bank, marked by the two trees in front of the caretakers' cottage, to a flat path following the Kitsilano Beach shoreline. The simple, rustic cottage is Park Board standard issue, familiar elsewhere in the city, although few are sited to such advantage.

BELOW

APRIL AT SPANISH BANKS

On a warm day early in April, with the snow still heavy on the distant mountains, most people are gainfully employed elsewhere, leaving the beach at Spanish Banks spacious and quiet.

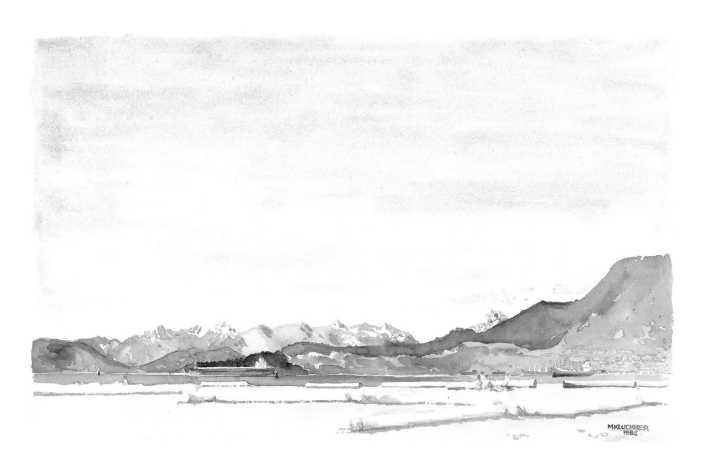

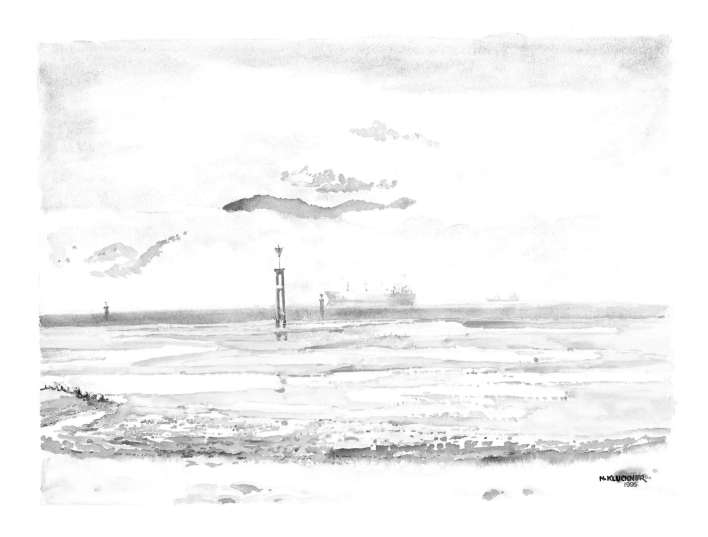

FOG BANK IN ENGLISH BAY

Sometimes in September the city awakens to a
heavy fog, which the late-summer sunshine quickly
burns off city streets and parks. But the cool
English Bay water keeps a fog bank hanging just
offshore, shrouding the patient freighters in a
damp chill, months removed from the hot sun on
the beach. Every few seconds the doleful, two-note
foghorn brays. At low tide the flats extend out
hundreds of metres into the bay, exposing the
bases of the radar towers that are usually successful
at keeping ships in the harbour's deep water.

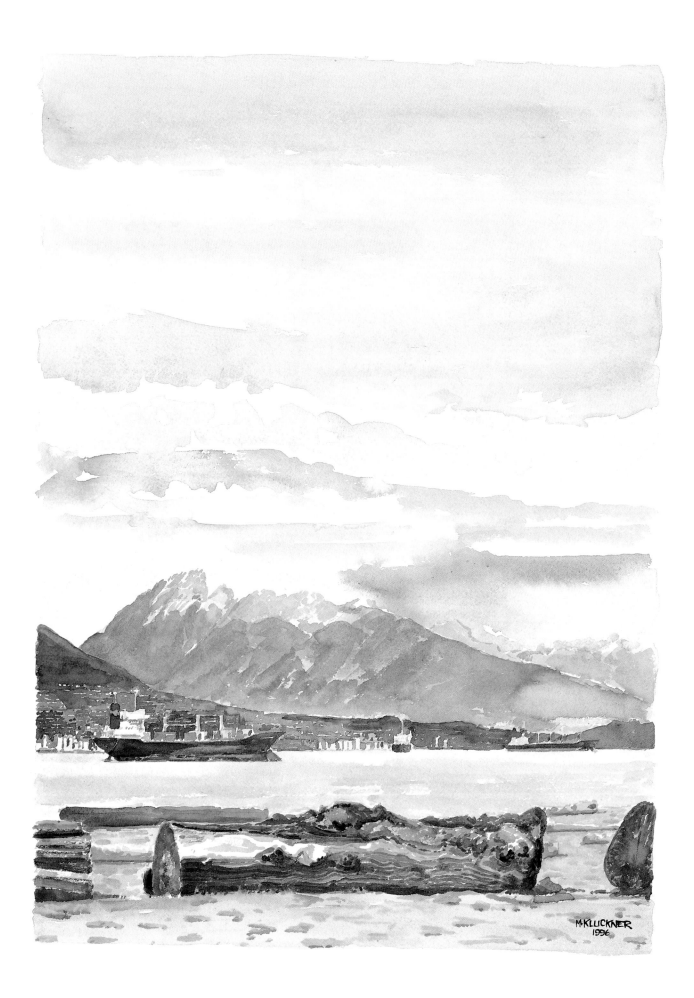

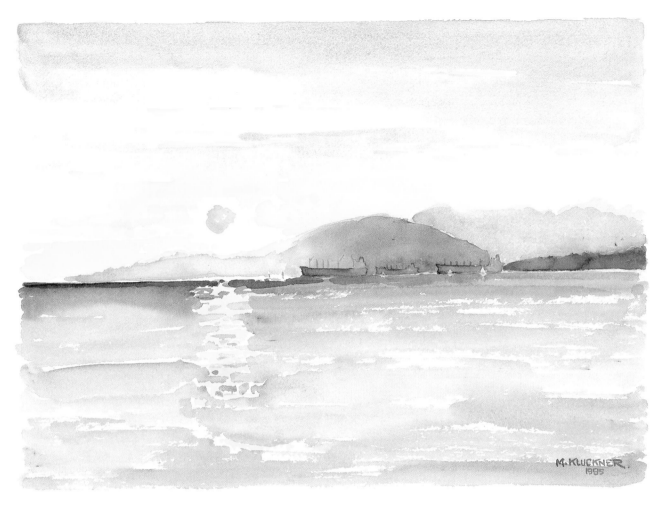

SUNSET IN JULY

From a comfortable bit of sand with a rock at my back on the beach near the foot of Macdonald in Kitsilano, I started daubing quickly at about 9:10 on a mid-July evening. The sun at that point, poised above Bowen Island, had just begun to strip the light from the day and cloak the hillsides in the blue haze that is the mother of the night. At 9:15 the sun kissed the Bowen hillside and five minutes later was gone.

HARBOUR IN WINTER

On some cloudy days in the winter, with no slanting sun to haze and dazzle, the light is surprisingly intense and clear, bringing even distant objects into sharp focus. Along Spanish Banks, where the logs have been neatly arranged for the following summer's sun worshippers, the patient freighters await their turn at the harbour's cornucopia. When a breeze blows over the water, English Bay becomes the faintest pale green beneath the grey sky; the light chop dissolves any reflection the empty freighters might have made, leaving them to float almost above the water's surface.

FAMILY NEIGHBOURHOODS

A lot of cities call themselves a "City of Neighbourhoods," and Vancouver is no exception. The corner store, the drive-in, and the slights and triumphs of high school, with names adjusted to suit the locale, create a Grandview, a West Van, or a Kerrisdale tale.

Stories about neighbourhoods usually hinge on how trapped their teenagers feel; they gain currency as individual teens struggle against the stifling conformity of their suburban block, their school, and their street of shops. It is the stuff of second-rate lives and first-rate novels. By that definition, the Vancouver I grew up in, in the fifties and sixties, ought to be the source of great stories. Kerrisdale during that era was exceptionally homogeneous, both racially and economically, but there was the glimmer of a more interesting way of life being born not far away in bohemian Kitsilano.

Most families had a single car, used by the mothers during the day while the fathers took the trolley to work downtown, arriving home every night at 6:00 or 6:05 after a brisk walk from Granville or Arbutus Streets. The Wednesday closing bylaw for stores was usually enforced, and Mr. Wyness, the butcher who lived across the street, was in evidence raking and mowing on that day. Office workers put in a half day on Saturdays, and there was nothing to do on the Lord's Day that wasn't an activity of one's own making.

We children were expected to get around on our own, by bike or by bus, even to the extent of going downtown alone and walking from the bus stop on Granville, along decrepit Nelson Street, past the gloomy Trafalgar Mansions to the YMCA on Burrard. It was a rare mother who picked up her child from school, even during torrential downpours, and now, from time to time, if I get really soaked, it brings back the memories of the aching arms and red hands and feet of a Vancouver childhood.

My mother shopped on the high street of Kerrisdale until Oakridge Shopping Centre opened in 1959 – a new experience that she took to like a duck to water. We knew the milkman by name. A Chinese vegetable dealer

also worked the neighbourhood in an old truck, and at Christmas he left lychee nuts for his regular customers. A middle-aged man, who today would be described as "challenged," came along the block every spring on a large tricycle; in the little box on the back of the bike he had brushes and tins of black and white paint, and for a small amount of money, probably a donation, he neatly repainted the street number of each house on the concrete curb. The Christmas season began when Japanese mandarin oranges, packed into their *wooden* crates, hit the stores. Families ran charge accounts at the neighbourhood grocers and butchers, so children, who were recognized and called by name by the proprietors, could pick up orders for their parents; you could even ask the butcher for a bone for your dog. There were two events of the year to save money for: the PNE at the end of summer and the firecrackers of Halloween. On Sunday mornings families dressed in their "Sunday best" streamed out of their houses and walked the several blocks to the neighbourhood church. Or so it seemed.

The old neighbourhoods were quite self-contained. Every neighbourhood had its own movie house, most being part of a Famous Players chain created in the early 1920s and wiped out by television before the sixties. The idea of driving all over the city to save 10 cents on an item here, another few cents on an item there, did not occur to many adults, whose memories of gas and tire rationing were still fresh from the war. There were no "category killers" or "big-box" retailers, except for Woodward's Department Store, and a day downtown on the tram included food shopping for the week, which Woodward's delivered the following day. Other than Theatre Row, only a handful of beacons, spawned by the car culture – the White Spot in Marpole, Wally's burger place on Kingsway, the Stardust roller rink in North Van, and a few drive-in theatres abhorred by girls' mothers – were bright enough to draw people away from their neighbourhoods.

The way the society of the time worked – mothers at home, sometimes a granny living with the family, pensioners on the block in the era before RVs, "snowbirds," and walled, age-segregated villages – there were fewer opportunities for people to get into trouble. Discipline for children included a sharp glance or word from *any* adult. The neighbourhood looked after its own, or so it seemed, and the television programs reflecting family life in the United States mirrored our own experience. They did not seem at the time to be parodies of a mundane suburban existence. Nobody had enough freedom, either economic or social, to have "nothing left to lose," as the song put it. We stayed fairly close to home, and freedom was always something we imagined would be wonderful when it happened to us at some point in the future.

Perhaps it was a golden age. There were fewer disaffected and dysfunctional adults, to be sure, than there are now, likely because they had gone through two decades of war and economic depression – the "been down so long this looks like up" syndrome. By today's standards the houses of the fifties and sixties were small and cramped. Fewer rooms had to be filled with furniture and there were fewer adult toys and appliances to buy; everyone had to share, especially the bathrooms. Dollars went further because expectations of material comfort and winter holidays and amusement were so much lower. One car and one job were often enough.

Since those good old days, the city's landscape of single-family homes has been transformed. The houses are bigger and there is less outdoors. Increasingly lifestyles focus on the private deck and backyard, and the view into the houses from the street is obscured by sheer curtains or drawn blinds. Although flower gardening has remained popular with many people, the old neighbourhood tasks of leaf raking and lawn mowing are often taken over by crews of hired "landscapers," whose weed-eaters and leaf-blowers turn fuel directly into noise. The evolution of the city landscape is especially noticeable from the back lanes: the family car used to live in a little hut or carport, which usually didn't have a door, and the back and side fences of properties were usually low pickets. Today the cars live in a house (with a drywalled interior, solid doors, and a security system), often two or three bays wide and occupying much of the lot's width, while the back fence has grown into the "Lumberland Special" – five feet of solid cedar with a foot of lattice atop it. Not a neighbourly fence, but one that reflects the nature of much of modern Vancouver.

WINTER AT THE LAWN BOWLING CLUB

Together with a pair of tennis courts at one end of a neighbourhood park on the borderline between the streets of apartments and those of houses, the Kerrisdale Lawn Bowling Club fits seamlessly into the neighbourhood, as it has since its establishment in 1915. In mild December weather the privet hedge surrounding the bowling green does not lose its leaves, and the grass stays green, if soggy. With the drier springtime days of March, the bowlers in their whites will begin to return to play the organized English version of the bocce played so casually by elderly Italians on the bumpy grass of parks in Grandview in the East End.

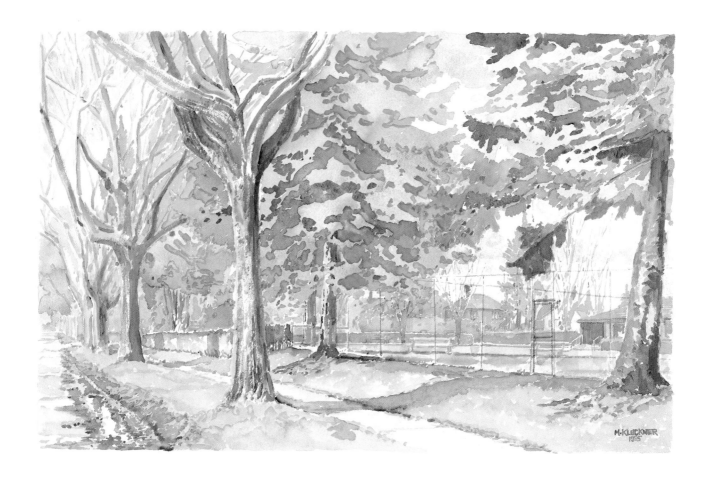

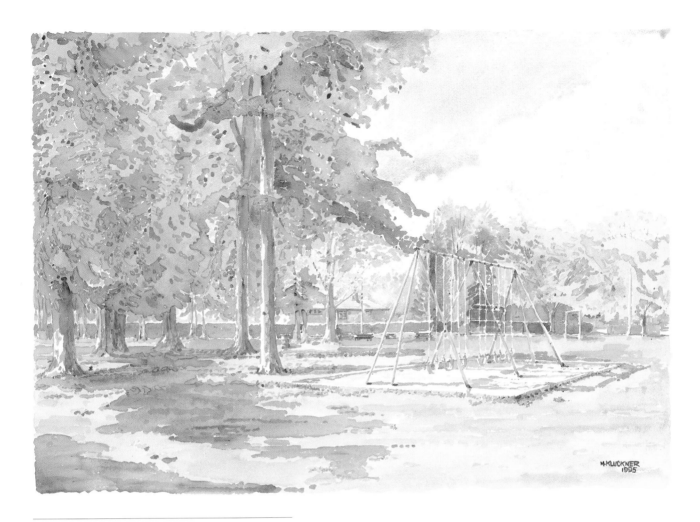

AUTUMN IN THE PARK

At Maple Grove, a neighbourhood park in Kerrisdale, it
is October, still summer weather in the day but cool and
dry at night, bringing on the subtle colours of the West
Coast fall. The children have returned to school, leaving
the park quiet and infinitely large, ideal for the handful
of people, some lounging with their thoughts or books,
others walking briskly in sensible shoes with well-
behaved hounds at their sides. A few parents, usually
alone, push strollers by as the dry leaves fall singly to the
ground, skipping and tumbling a time or two before
coming to rest on the exhausted grass. A group of moth-
ers, their tots around their feet like chicks around hens,
may happen by, and push the little children in a cursory
fashion on the swings, not pausing in their conversations,
before moving slowly along.

FOLLOWING PAGE

KERRISDALE

Although ravaged in recent years by develop-
ment, Kerrisdale still has streets of mellowed
houses and mature trees, where the church
steeples are as tall as the trees and are the focus
– in an aesthetic if not a religious way – of the
community. Standing at the corner of Thirty-
seventh and Larch for 85 years, St. Mary's
Anglican is a wooden version of the English
Tudor church in a North American facsimile of
an English village suburb. It is late in February,
a cherry tree is blooming in the left distance,
and the pale purple shadows of the leafless
maples stretch across the road.

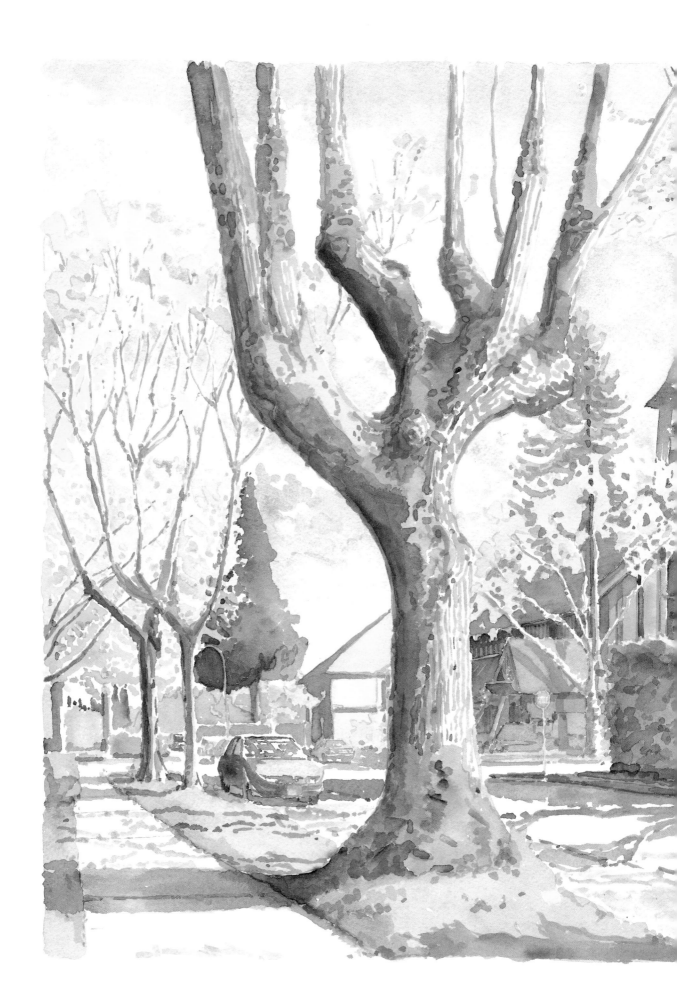

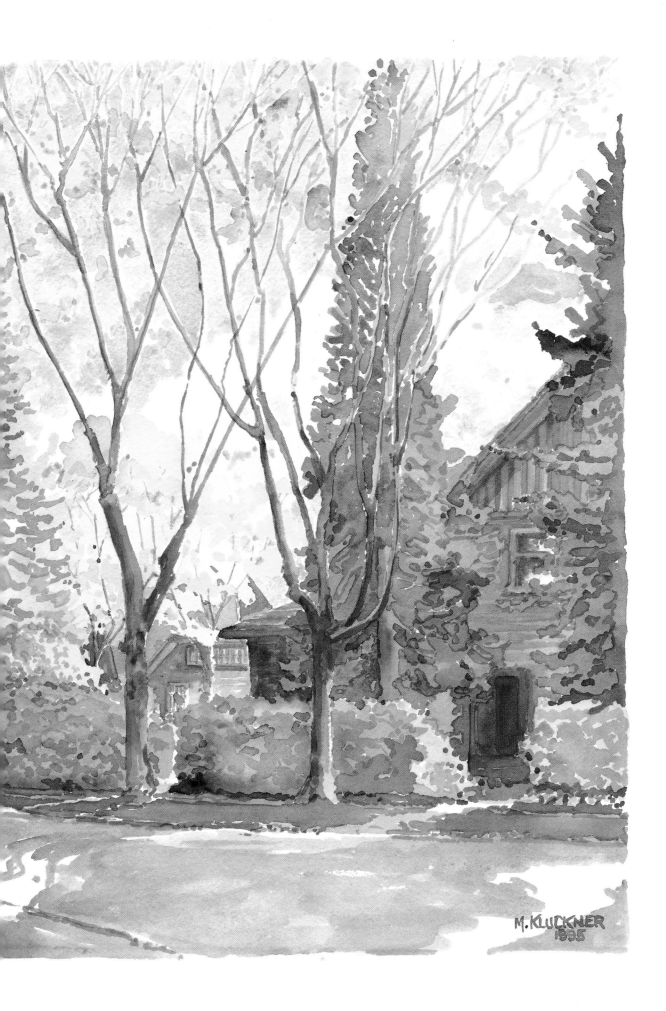

M. KLUCKNER
1995

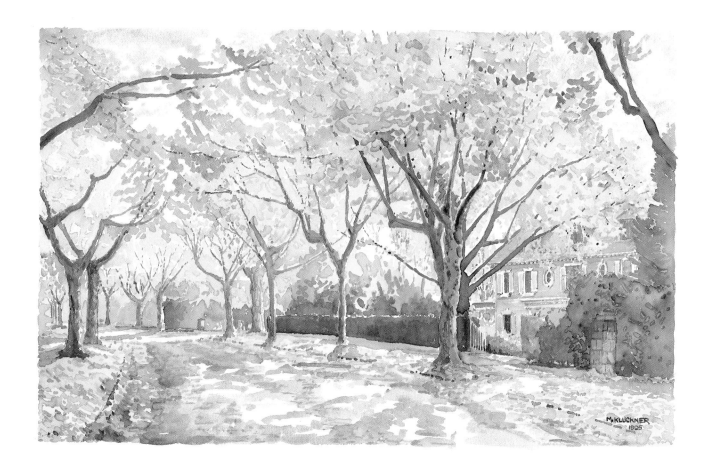

LEAFSCAPE IN SHAUGHNESSY

Vancouver autumns are children of the rain.
When the monsoon holds off until November, the
leaves stay brightly coloured and fall crackling dry
to the ground, ideal for scuffing by strollers or
scattering by bounding dogs. Usually, though,
there is a week or two of rain by early November,
sticking the leaves to the road where they are
mashed into a pumpkin-coloured pulp by passing
cars. The watercolour is of just such a November
on Pine Crescent in old Shaughnessy, on a day
when the low sun through the trees bathed the
road in amber light.

CANUCK PLACE, AS IT NOW IS

After decades as a private hospital, the huge Shaughnessy Heights house called Glen Brae was bequeathed in 1991 to the city. A spirited campaign of public support and a restoration transformed the building into a hospice for dying children, and it is now known as Canuck Place, after the city's hockey team, which played a leading role in the project. The Scots-born mill owner who built Glen Brae in 1910, mindful it is said of the manor houses he could but aspire to in his homeland, did not live to experience the matured landscaping that now closes Shaughnessy in on itself. Although the early owners may have had only small trees, formal plats of annuals, and garden statuary, they did have sweeping views all the way to the North Shore mountains (and great servants!), and their houses were a commanding presence on "the Heights." Today one comes upon houses such as Glen Brae – uh, Canuck Place – suddenly and almost unexpectedly. The watercolour shows it from the Matthews Street side, an angle from which the house's distinctive twin turrets – prompting its dated "Mae West House" nickname – are most visible. There was an attempt not long ago to renickname it the "Dolly Parton House," but it didn't work, probably because no one in the neighbourhood knew who the namesake was.

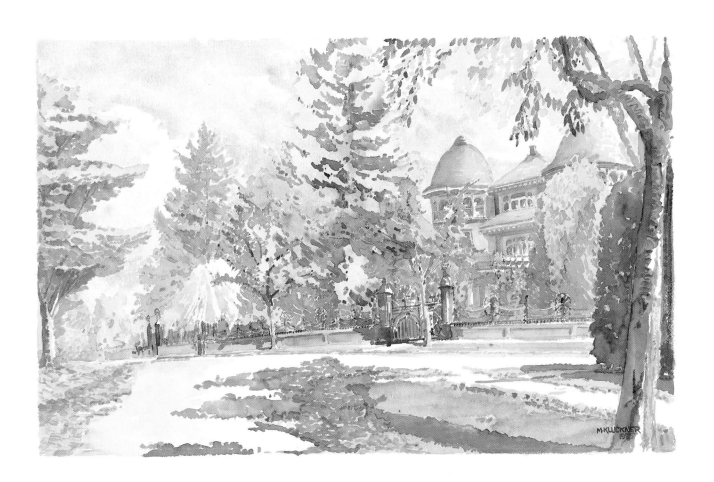

AFFORDABLE MECCAS

My neighbourhood of the fifties and early sixties was one of the contented stereotypes of secure family life in the Ozzie-and-Harriett landscape of postwar Vancouver, where families gathered around their televisions on Sunday evenings to watch Ed Sullivan. Subsequently there was for me a different type of neighbourhood, one of old rooming houses, street life, and relative poverty. For those of us who chose downward mobility as a lifestyle, Kitsilano was our mecca.

Kitsilano lacked the quality of suburban dreamscape that postwar Vancouverites craved. It suffered from the uncertainty caused by a zoning prescription established years before, which envisaged ranks of apartment buildings abutting industrial False Creek and buffering the desirable, leafy single-family neighbourhoods of Shaughnessy, Kerrisdale, Dunbar, and Point Grey. According to the planning dogma of the time, Kitsilano's location within the inner ring of old Vancouver streetcar-suburbs made it unsuitable for the good family life.

By the sixties, absentee owners of many of the old family homes were waiting for apartment redevelopment, and their 1910-era houses were in a state of slow decline; having been well built of first-growth timber, they were so solid that routine maintenance could often be overlooked. Eventually the house was going to make a trip to the municipal landfill and, besides, the tenants were easygoing, unfussy, and often stoned. Like San Francisco's Haight-Ashbury, Kitsilano had the perfect stock of housing for shared, low-budget living, its own Golden Gate Park in Kitsilano Beach, and, for the Easter Be-In, Stanley Park. Nearby was the University of British Columbia, its students a ready market for cheap housing. On Fourth Avenue low rents and vacant storefronts attracted a number of businesses owned by the new residents, including the Village Bistro, the Lifestream organic food store, The Naam vegetarian restaurant, and the Acme Two-Step Dancing School and Emporium. Today only The Naam, with a new cappuccino machine, survives.

Kitsilano was as Morag Gunn found it in Margaret Laurence's *The Diviners*: boardinghouses "last painted around the turn of the century," their faded

colour "the light sea-bleached grey of driftwood, silver without silver's sheen."
They were "firetraps, lived in by people who can't afford to live anywhere else,"
but their lack of pretension made them preferable to the "jazzy split-level hous-
es" that were the norm on the slopes of West Vancouver. West Van houses were
home to the upwardly mobile, such as brokers on the roller-coaster Vancouver
Stock Exchange, many of whom had become millionaires in the mining boom
of the early sixties. They had sideburns and wore tightly cut suits, and their
women favoured miniskirts and Audrey Hepburn hairdos, the stuff of count-
less *Western Living* magazine articles. The men drove American cars daily across
Lions Gate Bridge to offices in new downtown towers like the Bentall Centre –
the sort of architecture that made you want to put on a suit or, more to the
point, made you feel out of place for not wearing one.

In Vancouver the sixties continued until about 1975 and then ground sud-
denly to a halt as many of the participants discovered family life and the joys of
cash flow. The counterculture became the over-the-counter culture. The first
sign that the light at the end of the tunnel was, in fact, a train was the mini
real-estate boom of 1973, when house prices doubled in a flurry of speculation.
Real estate went crazy again in 1980, during the age of the monetarists and 18
percent mortgage rates, and yet again in 1988 and 1989; each time more of the
affordable old houses came down or were converted into condos, old people
cashed out and left the neighbourhood, and Vancouver became more stratified,
with the haves over here and the have-nots somewhere else.

Not surprisingly Kitsilano has reinvented itself as a home for the haves. On
some streets the old doss houses have been beautifully restored as heritage
buildings, returning them to the single-family dream of 1910. There are fewer
people living in these houses today than there were in 1970, but they all own
cars, and some even have nannies. On the slope above the beach childless
adults live in stylish condominiums. It is easy to walk to a downtown job (as
witnessed by the people wearing business clothes and sneakers streaming across
Burrard Bridge in the morning and afternoon), or to the market at Granville
Island, or to browse in the bookshops and Greek delicatessens of Fourth and
Broadway. Adam Smith's famous axiom applies to the neighbourhood: there is
more demand for it than there is supply, and so the old affordable Kitsilano of
the sixties has all but ceased to exist.

Youth with its (leftist) political and activist culture, no doubt angrier and
more disaffected than a generation ago, migrated eastward, populating Main
Street for a time, then Strathcona, before the yuppie legions pushed it to its cur-
rent defensive position along Commercial Drive in Grandview. "The Drive" in
the early seventies was the miracle mile of social service agencies, a benefit
bestowed upon it by local boy Dave Barrett, the provincial premier of the period;
it has been since the Second World War and still is the Italian neighbourhood,
and the old-timers coexist uneasily over their cappuccinos with "the ferals." The
punk style of black on black, spikes and piercings, having surfaced in the late
seventies, has been remarkably durable, much more so than the beads and
fringed buckskin and floppy hair of hippieland Kitsilano. But if Vancouver his-
tory is anything to go by, the affordable rentals of Grandview will soon be a
thing of the past, and the Italians of "The Drive" will find themselves gazing
through their espresso steam at nannies and designer strollers.

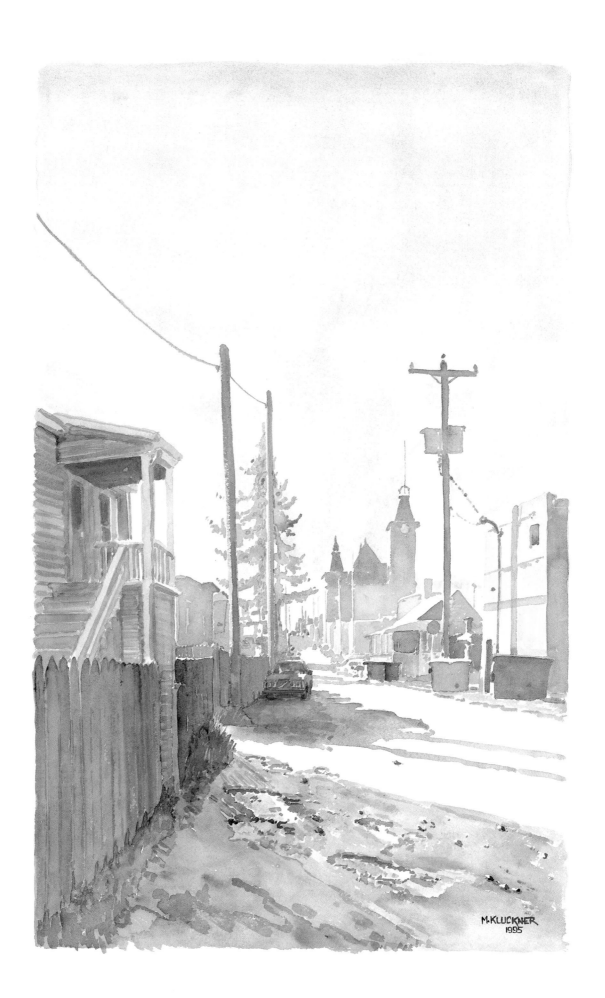

M. KLUCKNER
1995

FROSTY MORNING ON WATSON STREET

On a winter's morn the fairy-tale turrets of the old post office on Main Street rise above the modest rooftops of the East Side like a palace above the hovels of the serfs. But it is perhaps a more democratic scene here, demonstrating little more than the poor luck of some property owners, the modest means of some freemen, and the influence of a forgotten Member of Parliament in a young city. Built in 1915, the post office was designed by Arthur Campbell Hope, an architect whose legacy survives mostly along the sleepy main street of Fort Langley; it was restored for community use in the 1980s and is now known as Heritage Hall. It remains as one of a handful of optimistic buildings on Main Street which, in the period before all the optimism, was known merely as Westminster Avenue. The view looks along Watson Street, a curious lane a half block east of Main, running south from Broadway to Main Street's curve at Eighteenth. Cabins face Watson and a number of the other streets in the area, in mock salute to the great expectations of the early years of the century.

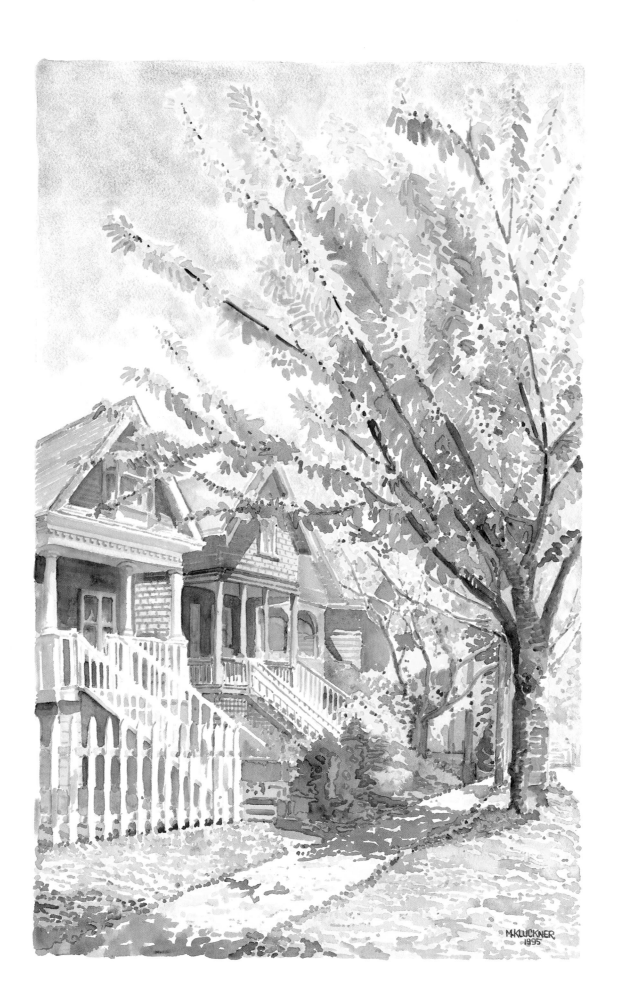

McLUCKNER
1995

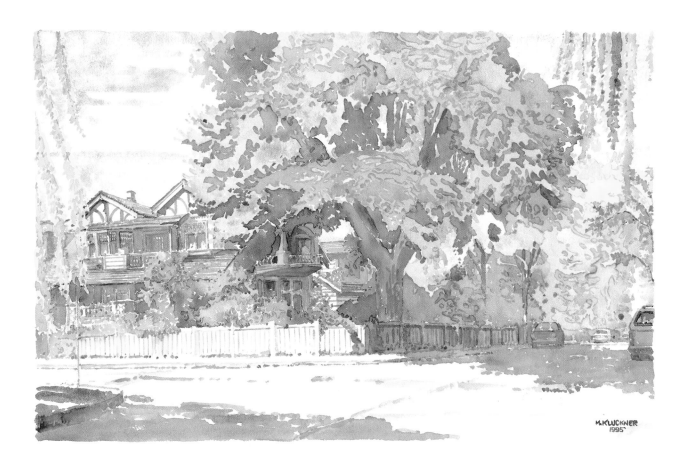

AUTUMN COMES TO KITSILANO

The northwestern corner of Kitsilano, adjoining Jericho
and the waterfront, was developed before the First World
War as a poor man's Shaughnessy Heights. Although the
homes were large and superbly built, with hardwood
floors, leaded glass, panelling, and cabinetry of a very
high standard, the lots were small and the area was a bit
suspect, being within sight – across a swamp – of the
Jericho school for wayward boys. But in the 1920s the
swamp was drained, Jericho developed a prestigious golf
course, and the reform school moved to Coquitlam. It
was a brief heyday that ended after the Second World
War when the fine homes that had survived the tenancies
of the wartime housing shortage were roughly converted
into rooming houses and became the stage for Kitsilano's
passion play of peace and love in the 1960s. Since then,
new owners – in some cases 1960s-era tenants – have
carefully restored the houses, returning the area to its
original glory. The watercolour looks west on First
Avenue at Dunbar past a Craftsman-style house with a
copper beech tree in its side yard.

BLOSSOMS ON QUEBEC STREET

The extension southward of the Main Street tram in 1904 to provide
access to Mountain View Cemetery and the gravel pits on Little
Mountain also opened up for subdivision and suburban development
the land holdings of some shareholders in the electric railway compa-
ny. East of Ontario Street – the eastern boundary of the Canadian
Pacific Railway's 2,450-hectare holding – landowners held small parcels
that they surveyed willy-nilly, creating a haphazard lot-and-street pat-
tern in sharp contrast to the ordered, methodical subdivisions the CPR
developed. West Side people, who bought from the CPR, obeyed the
building covenants and kept out the riffraff; they voted for politicians
who supported good zoning, inspection, and tax-collection practices,
and who believed the East Side to be little more than a slum. Naturally
prices were lower on the East Side, leading to a much more diverse
rabble of buildings, but in the decades since then sophisticated home-
owners have learned to cherish the character afforded by what were
once undesirable neighbourhoods. This row of houses, on Quebec
Street near Twenty-eighth Avenue, was a block from the Main Street
tram and a block to the east of the Ontario Street "boundary."
Plantings of Kanzan cherries, which bloom in the dancing blue light of
March, deposit on the street the only snow a true Vancouverite can
tolerate – the pink kind.

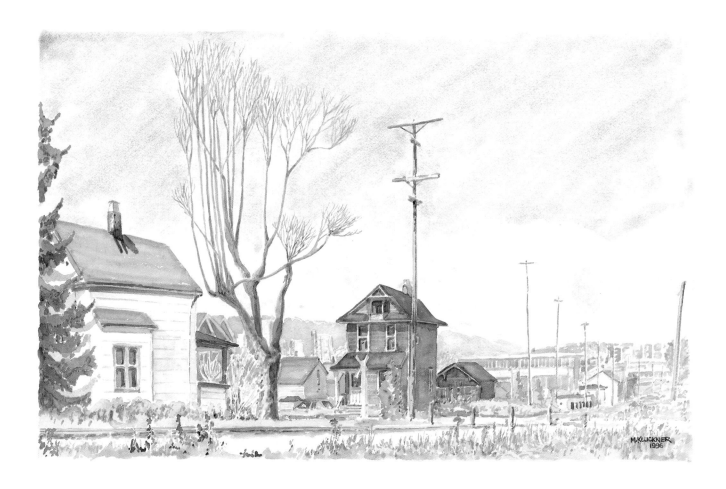

RAILWAY CROSSING AT CYPRESS STREET

The last remaining pocket of "old" Kitsilano – that is, the neighbourhood of rooming houses and weathered buildings so evocative of the hippie sixties – occupies the few square blocks between Fourth and Broadway, Arbutus and Burrard. One reason for the lack of change here has been the railway track, in a more progressive age (1905) the interurban train line connecting Steveston with Vancouver. In the 1960s and 1970s, the right-of-way was envisaged as an arterial commuter road-way, so landowners sat on their hammers and did nothing while they awaited a decision; in the 1980s and early 1990s, it was to become a rapid transit line, so again the owners held their breath. Except for the glimpses of downtown and mountains, the scene could be from a midwestern industrial town – an old part of Winnipeg, perhaps, where the houses stand tall and proud along the streets, old deciduous trees tower above them, and a sleepy spur line connects the local furniture factory with the outside world.

WINTER AFTERNOON ON THURLOW STREET

From Thurlow Street just above Pacific Avenue in the West End there is a peekaboo view southward to the superstructure of the Burrard Bridge with, in the distance, the "spine" of Vancouver – the ridge that runs from Point Grey eastward through "the Heights" (Dunbar, Mackenzie, Shaughnessy, and so on, beloved by early real-estate promoters and "Vancouverheights"), dividing the city into a harbour-facing half and a delta-facing one. On winter afternoons the deck of clouds over the city often breaks up to the southwest, showing just enough blue sky "to make a sailor a pair of trousers," as my mother-in-law would say, below which bands of cream and orange foretell the sun's setting. The high-rise apartment building, Martello Towers, was one of the contributions to the skyline of developer Tom Campbell, mayor from 1968 to 1972, whose vision of a Miami or Rio beachfront along English Bay has evidently not been unanimously endorsed.

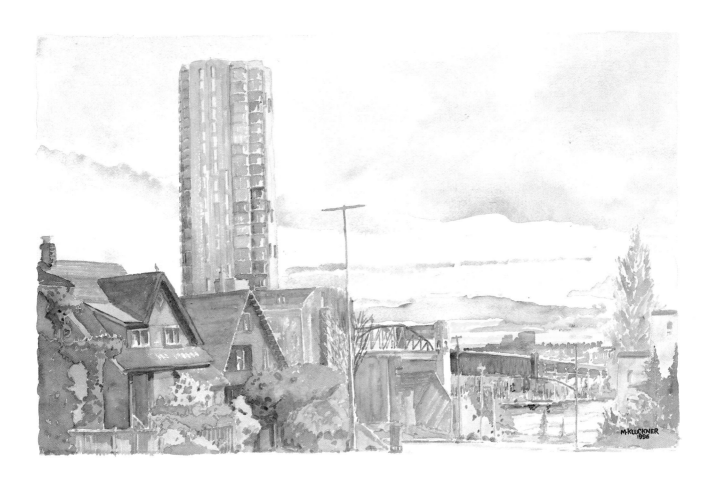

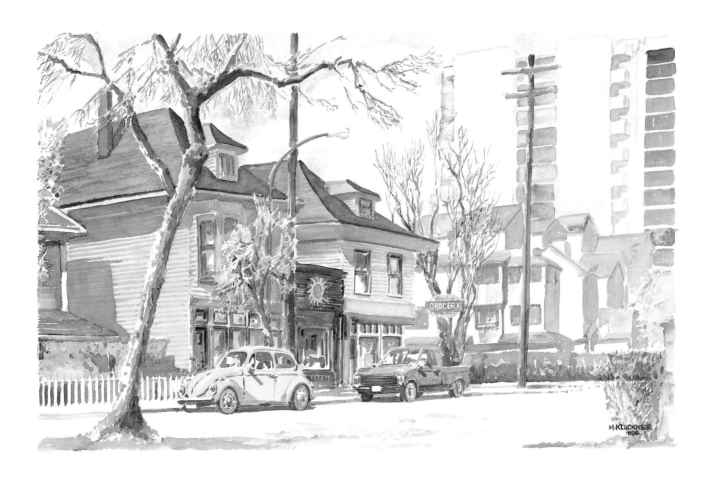

BARCLAY GROCERY

The old grocery store at Barclay and Nicola is one of a half-dozen commercial islands in the sea of apartment buildings that is the West End. With its mature trees and quiet streets, this enclave of the West End looks inward rather than outward toward mountains and water as most other Vancouver neighbourhoods do; it is reminiscent of old parts of cities that lack topography, like Toronto. The West End's corner groceries have been a part of city life since the earliest days, like the Nine O'Clock Gun and sweaters on summer evenings, and still thrive because most people get around on foot or by bicycle. Elsewhere in the city, corner groceries are gradually disappearing, unable to compete with convenience stores in mini-malls and the "town pantries" at gas stations that offer a quick in-and-out for people in cars.

EAST PENDER STREET

In Strathcona east of Chinatown the St. Francis Xavier Church occupies the high ground on Pender Street and ministers now to a Chinese Catholic congregation, part of the postwar wave of immigrants to the neighbourhood, successors to the Swedes, Greeks, Ukrainians, Jews, and Italians for whom Strathcona was a first Vancouver home. An even more recent wave of immigrants has been drawn to the picturesque architecture of the neighbourhood: young professionals are ministering with paint and patches to many of the old houses. The sidewalk along Pender is busy with people who walk to and from Chinatown's shops, a few blocks past the crest of the hill, for their groceries.

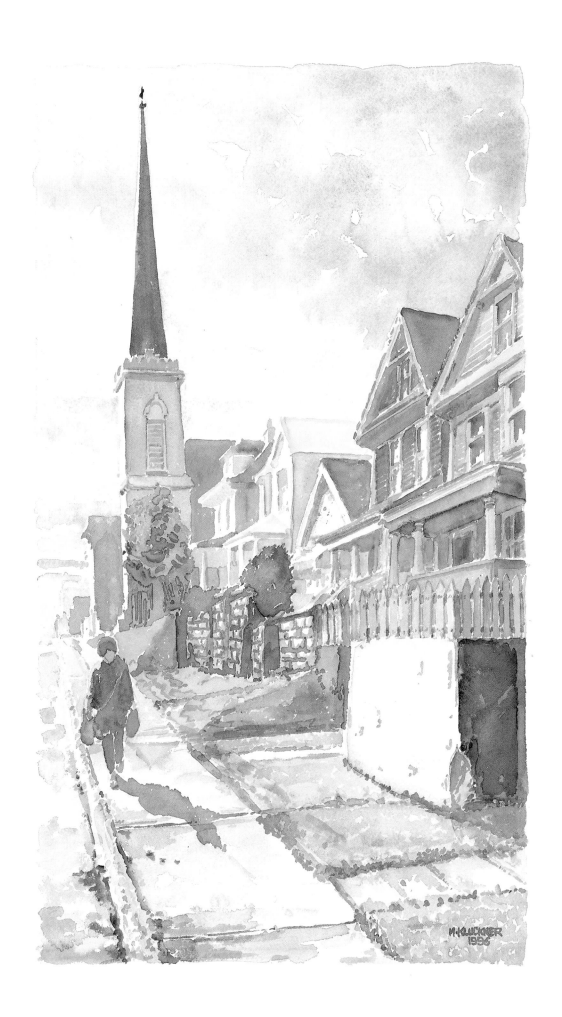

M KLUCKNER
1996

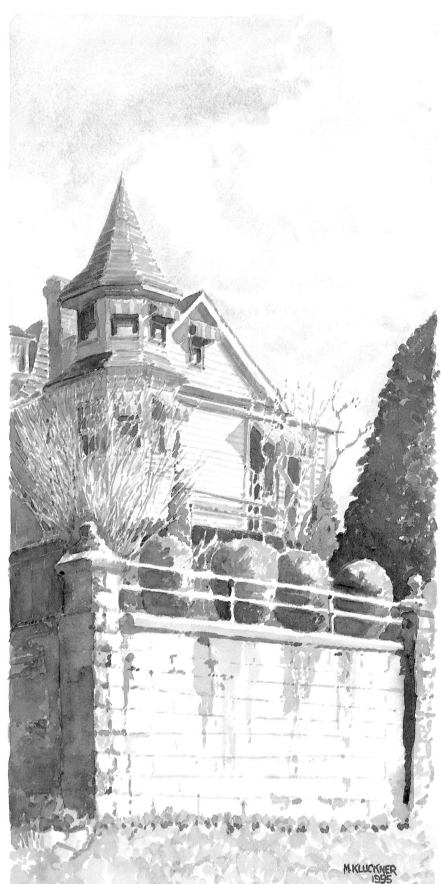

M·KLUCKNER
1995

GLEN HOSPITAL

Grandview is the city's finest remaining Queen Anne neighbourhood, with many of the characteristic turrets positioned to take advantage of the grand view to downtown and the mountains. Most of the big houses date from before 1910, a time when granitelike concrete blocks were manufactured in great abundance, real granite being expensive and scarce since it was quarried only on small islands in the Strait of Georgia. On the hilly Grandview streets there are probably more concrete blocks supporting houses and holding back hillsides than anywhere else in the city. The watercolour shows the retaining wall of Glen Hospital on Salisbury Drive, built as a home by a prosperous, Australian-born realtor who lost his fortune almost as soon as he had made it; for decades the hospital has maintained the formal, clipped shrubberies of his fashionable Edwardian garden.

OPPOSITE

CITY HALL

One of Vancouver's idiosyncrasies is the location of its City Hall: it stands on the edge of an old residential neighbour-hood rather than in the middle of the downtown business district, as is the case in most cities. The original city hall was, in fact, at the heart of things for most of the city's first 50 years of existence, being near the corner of Hastings and Main in what is now the city's skid row or tenderloin. In the early 1930s, however, the city decided to build its new headquarters south of False Creek, near what had been the boundary between Vancouver and the two adjoining municipalities with which it had just amalgamated. The painting looks across Yukon Street, past a 1909 house now converted into apartments, to City Hall's Moderne facade on Twelfth Avenue at Cambie.

FOLLOWING PAGE

NEW WESTMINSTER

Although it is the oldest colonial settlement on the B.C. mainland, New Westminster was bypassed by the glory train more than a century ago when the transcontinental railway built its terminus on Burrard Inlet and created Vancouver. On many of its streets, especially in the Queens Park area, a charming, small-town peace and quiet still clings to the houses and gardens, like the setting for a 1940s movie. With little traffic, and only the occasional pedestrian passing by for most of the day, it is a gracious neighbourhood where a bank branch manager's family might have resided next to the owner of the five-and-dime. The painting looks south along Fifth Street toward Fourth Avenue and beyond – two narrow traffic lanes paved with concrete and patched with tar, separated by a narrow boulevard planted mainly with different types of holly. There are many other City Beautiful-style boulevards in the Lower Mainland – King Edward Avenue, Sixteenth Avenue, Cambie Street, and Grand Boulevard, to name the major ones – but, when compared with Fifth Street, all of them are wide, rather pompous, and wildly out of scale with the stucco bungalows lining them. Only Osler Street in Vancouver's Shaughnessy Heights has big houses to match its boulevard. On this winter day the world was sat-urated with rain, and the moss in the lawns and on the trees glowed like jewellery. From time to time a watery sun made a brief appearance, low in the sky to the south.

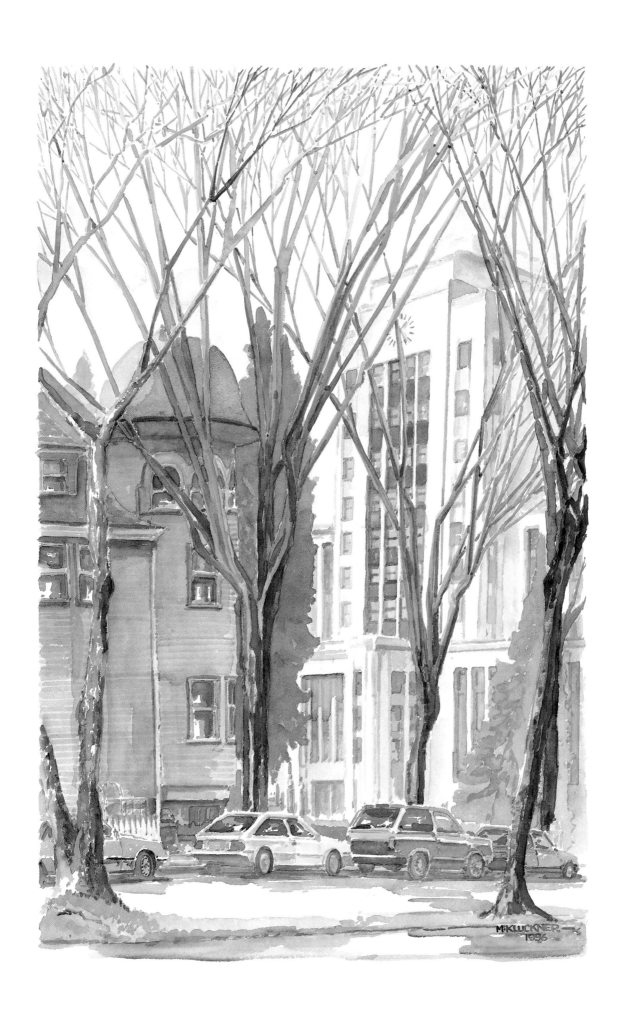

M·KLUCKNER
1996

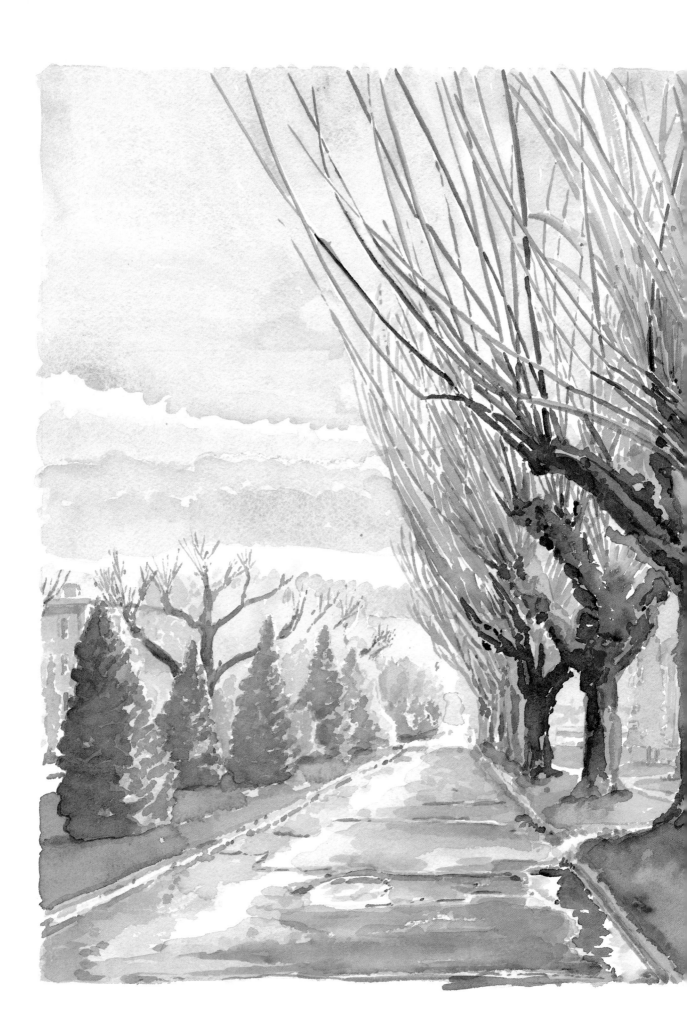

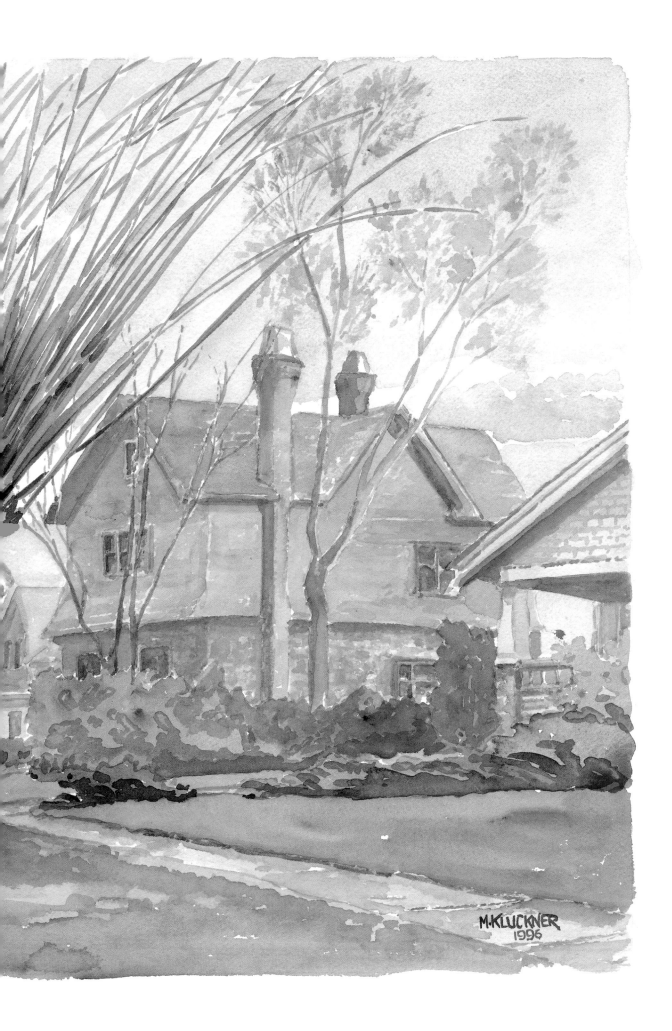

M.KLUCKNER
1996

Mountains and Water

It has always seemed to me that the North Shore is a state of mind as much as it is a place to live. More than the Vancouver neighbourhoods that focus naturally on the downtown, or the suburbs to the east and south that focus on their malls, the North Shore neighbourhoods define themselves by the wild mountains and ravines in their backyards. The people along the shoreline, especially out toward Point Atkinson to the west and Deep Cove to the east, live facing their classic West Coast landscape of rocks, wind-blown trees, and grey waves. It is a combination summed up in the cliché about Vancouver being a place where one can ski in the morning and sail in the afternoon.

I have always had the impression – the kind of impression that should never be spoiled by research – that there are North Shore people and then there are the rest of us. A certain type of human seems to arrive there, either by birth or migration, and then stay put, whereas the rest of the population could never feel at home with the mountains at their backs and only the two bridges at the narrows and the little SeaBus to connect them with the city.

The human relationship with the wilderness on the North Shore is a complex one. Cities all over North America may have their raccoons and coyotes, but the North Shore has deer and even bears, sometimes discovered scarfing happily through well-stocked middle-class garbage cans. From time to time a cougar is spotted, a welcome change from the usual predators in modern urban residential areas. Occasionally "unnecessarily tall trees," as one speaker at a public hearing described them, get lopped for the sin of view blocking, but in most cases the residents coexist with their enormous, dripping cedars and Douglas firs. Over the years the building line has crept up the mountainside toward the snow line; on the steep lots, among the trees and rocks high above the city, driveways are heated to keep the homes usable all winter, but the electricity comes from a flooded wilderness somewhere else.

However, in recent years, the snow line, already pushed east by the urban

heat island, is also being moved farther up the mountains by all the cars and the homes exhaling their warm breath into what used to be a cold sky. It has become rare, around Burrard Inlet, to see the opaque grey sky of an impending snowfall, and snowfalls on the higher levels of the North Shore mountains seem to occur just often enough to keep the ski operators clinging to solvency. Such snowfalls are a welcome sight from the city below, giving the forested parts of the mountains the colour and texture of a tousled raccoon.

In the early part of the 20th century there was a lot of usable land in both North and West Vancouver on the gentle slopes bordering Burrard Inlet, offering residents a great choice of south-facing homesites, but the similarity ended there. In North Vancouver industry and workers' housing dominated the foreshore, while in West Vancouver no industry – other than transient sawmills and canneries – was ever allowed to take hold. North Vancouver always wanted to be big-time, with its Edwardian parks, especially Victoria Park on Lonsdale Avenue, and its broad City Beautiful-style showpiece, Grand Boulevard. But it ended up with shipyards and bulk-loading terminals, railway yards and grain terminals, and an economy that has been flat for much of the century.

But the wilderness still beckoned and the population – mainly people with Vancouver jobs – slowly grew. My parents were content to live in Vancouver and take Sunday drives to the North Shore – in retrospect, the only place we ever went in that era when the city was shut up as tight as Andronicus for the Lord's Day – to admire the rushing freshets and the huge trees, to walk across Capilano Canyon's suspension bridge, and to comment on how the ominous clouds above didn't seem as prevalent over Kerrisdale. They were from the East, Ontario and Quebec to be exact, where there are skies larger than the little disc of grey between the treetops offered to residents of the rainforest. When we didn't picnic among the boulders on the shore of the Capilano River, with our two-burner Coleman stove and Melmac plates, we lunched at the Tomahawk Barbeque, then a log cabin on Philip Avenue just off Marine Drive, a highlight after a long morning in the car for a hungry, grubby little boy like me. Today, with North Vancouver's Marine Drive a rival for the garish strips of Vancouver's Kingsway or Surrey's King George Highway, the Tomahawk (even in its new building) has a quaint appearance – a relic from an era of cigar-store Indians and beaded, thunderbird-decorated belts that declared WELCOME TO VANCOUVER.

West Vancouver was quite different than North Vancouver, succeeding for the most part in carving out an individual identity as a seaside place – a woodsy, English-style Santa Barbara where quality of life was more important than the size of the tax base. Old West Van still has its ferry building at the foot of Fourteenth Avenue, a relic of the service that transported the first commuting settlers in the decades before Lions Gate Bridge opened, and its grid of streets – the numbered north-south ones and the alphabetical east-west ones from Argyle at the waterfront to Queens on the heights above. People who lived there in the years before Lions Gate Bridge opened in 1938 accepted some inconvenience in return for their sloped, south-facing gardens. One house from that period stands at Nineteenth and Inglewood, the one with the lych-gate; on winter mornings when he walked to the ferry slip, the owner carried a lantern with him that he left hanging on a fence for his return walk along the muddy streets after a day at work in the city.

In the automobile age, which began in West Van in the mid-1920s, people built along the shoreline to the west of Dundarave. There Marine Drive is cut into the rock face and small garages abut the road on the waterside, with stairs descending from them through steep gardens toward cottages – often pleasantly bedecked with wisteria and honeysuckle – tucked into the rocky coves below. The Douglas firs along the shoreline have branches swept back by the south-westerlies like stiff, unwashed hair. In the tops of old trees, 50 metres or more above the ground, eagles nest; the forest floor is a thicket of salal and salmonberry, occasionally punctuated by the harsh orange bark of an arbutus tree with toelike roots tenaciously grasping the gaps between plates of rocks. Seals sometimes bark in the choppy water lapping at the rocks.

The sea and shoreline meet in a rolling canvas of greys, blues, and cold, wet greens. To the west, on fair days, the distant mountains of Vancouver Island rise above the Strait of Georgia, while to the east and south, across English Bay, the regular ranks of Vancouver's buildings stand in the haze. But the old West Van of eccentric cottagers and picturesque lanes is fast disappearing under the recent onslaught of "Big Pink"; large, pastel-coloured houses now loom uncomfortably above the rocky outcroppings, unlike the old cottages (and even the radical, flat-roofed split-levels of the fifties and sixties), which seemed to grow out of the landscape.

From the earliest days of white settlement the mountains attracted hikers. One story tells of the young Arthur Dalton, later to be a noted architect like his father, ascending Grouse Mountain and planting a flag, visible by telescope from the family home on Coal Harbour, to honour Dominion Day. Using lumber salvaged from abandoned sawmills and from the box flumes of early water supplies, industrious hikers built cabins high up on the mountainside, initially on Grouse, then in the 1920s on Hollyburn and Seymour. In the years before the Number One tram was extended north on Lonsdale to Windsor Road, a hike to the summit of Grouse Mountain took three days – the first from the ferry dock at the foot of Lonsdale to Trythall's Cabin near the modern chalet parking lot, the second to the top, and the third all the way back. Once the tram went in, winter hikers, although weighed down by heavy woollen plus fours and wooden skis, could quickly reach the base of the mountain, from where it was an arduous but relatively brief hike up the logged-off slopes to a point where, exhausted by climbing, they turned briefly into skiers and streaked back downhill. A couple of runs and the winter daylight would be gone.

Grouse was where the commercialized mountain experience, including skiing, first established itself on the Lower Mainland. In 1924 the Grouse Mountain Chalet, a rustic log building financed by a local bakery owner, opened for business at the top of a paved toll road. This first enterprise foundered in the Great Depression of the 1930s; the modern operation, with its chairlift to the top of the mountain, began after the Second World War as a venture of Marwell Construction, with subsequent backing by the *Vancouver Sun.*

Hollyburn Mountain took a lot longer to become commercialized. Its old lodge, built in the mid-1920s, became the centre of a village of chalets and cabins, some operated by organizations like the YMCA, others privately owned, all reached by a steep hike through the snow. Riotous parties were not uncommon

in the little community. The third mountain, Mount Seymour, got a road during the war through a project employing conscientious objectors, and it got its first rope tow in 1949; the surrounding provincial park soon offered some of the best mountain hiking in the Lower Mainland.

The last hurrah for early Vancouver's freewheeling relationship with its mountains occurred on Hollyburn in the years before the cross-country skiing area was privatized by the provincial government in the early 1980s. Although downhill skiers paid lift fees at nearby Cypress Bowl as well as at the private operations on Grouse and Seymour, the cross-country skiing trails on Hollyburn – a network of old hiking trails connecting the cabins around Hollyburn Lodge with Westlake Lodge – were free. In the 1970s a motley collection of people in tweeds and toques, some on snowshoes, some with toboggans or sleds, and some with cross-country skis of various levels of sophistication, bumbled about, fell, executed daring telemarks or pedestrian stem christies, and snowplowed their way around the old downhill skiing area. Soaked, numbed amateurs steamed in the humid lodge over their hot chocolates.

Then came the fees, signs saying KEEP RIGHT and CAUTION, and closed trails on weekdays to make the flow of skiers more manageable. A new generation of skate skiers began to dominate. They were really far too athletic, muscles rippling beneath their gleaming spandex bodysuits, ostentatiously performing multiple deep knee bends after sprinting up steep hills. A sign was added to the road up to the ski area announcing that "tubing" was prohibited – even the verbs were new.

With the demise of those good old days, I began to reevaluate my relationship with winter. It was all downhill from there. Whistler, and its younger sister Blackcomb, had little appeal, as it required a gargantuan effort to earn the money to get the gear to make the trek to buy the beer. We decided to stay home and read seed catalogues and watch for the early irises and snowdrops breaking through the soaking brown soil of the garden. When the snow came to the city, we could go to local parks with steep hills, like Little Mountain, and watch the children laughing and squealing as they spun and slid on pieces of cardboard, laminated-wood toboggans that looked like surplus from a National Film Board feature on rural Quebec and, yes, inner tubes. After all, doing anything more with winter was a bit too Canadian for a Vancouverite.

FOLLOWING PAGE

GAS BAR AT DEEP COVE

Something of the agreeable shabbiness of the old-time waterfront clings to Deep Cove at the extreme eastern end of North Vancouver. In that long-ago time there was more waterfront than there were people – certainly more than there were people with the money to be yachty and do things *properly* – so small-boat docks were shallow-set pilings, with the narrow wharves lashed between them rocking with every swell. Simple buildings were hammered together and quickly became stained by lichen, their plywood siding buckling in the permanent dampness. Many of the boats were home-built skiffs of sheets of plywood pinned together by caulked nails, and the water around the docks and near the outboard motors always carried a psychedelic light-show sheen of gas-oil mix. The painting looks south past the gas bar at the Deep Cove Yacht Club, toward the narrows where Indian Arm swings north from Burrard Inlet. It is November, in a pause between downpours, with the clouds taking the opportunity to reposition themselves among the trees on the steep hillsides.

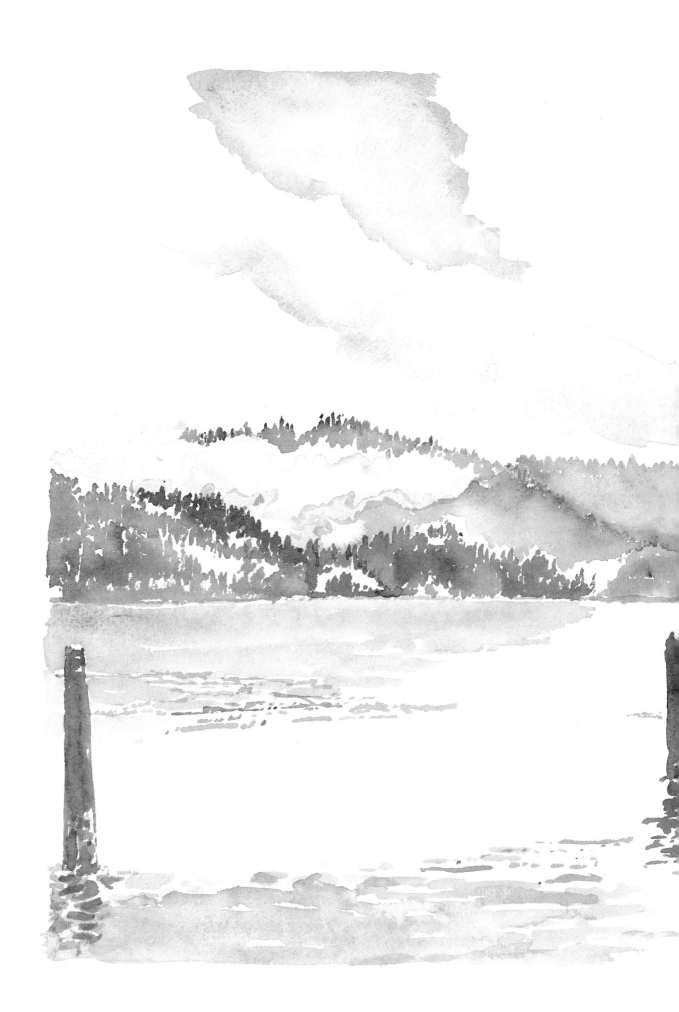

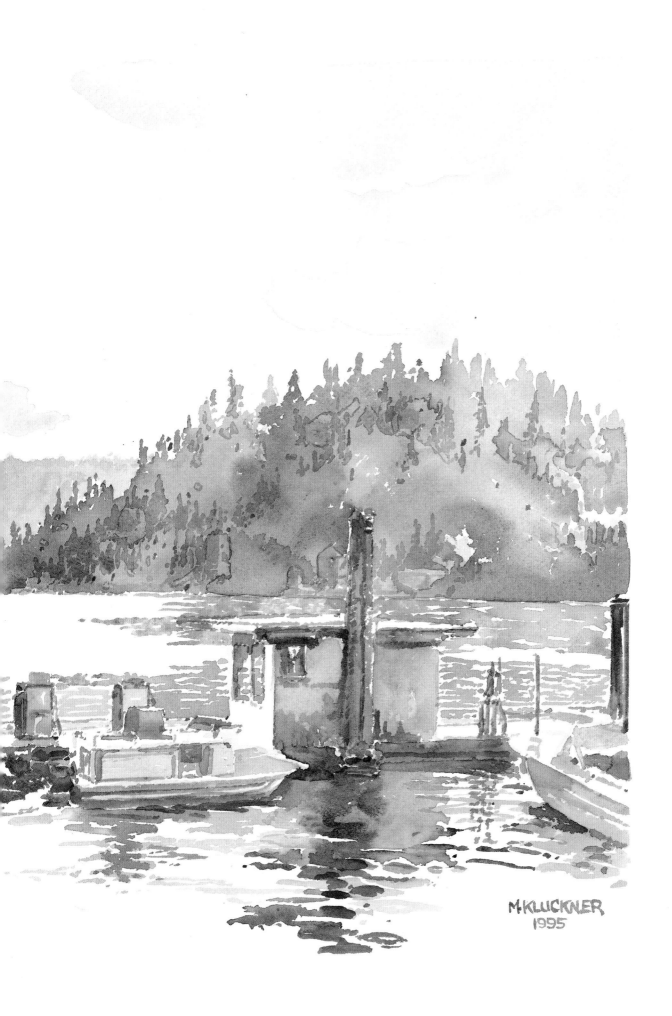

M·KLUCKNER
1995

STORM CLOUDS OVER BURNABY MOUNTAIN

East of the Second Narrows Bridge, Burrard Inlet becomes a narrow channel wedged between Seymour and Burnaby Mountains. During the tremendous autumn rainstorms dubbed "the Pineapple Express," warm and cold air mix and the thermals lift tendrils of clouds among the trees along the face of Burnaby Mountain; the clouds curl over the crest like the fingers of a ghost's hand and then sweep down the south-facing slope away from the inlet. The buildings in the foreground are part of the last operating shipyard on what was, at one time, a very industrial stretch of the North Vancouver waterfront. The first industry there was the Dollarton mill, with its own workers' town, at Roche Point, established by the Robert Dollar Company in 1916. Nearby foreshore on the Maplewood Mud Flats has been cleaned of shacks and industrial spoil and returned to wildlife habitat through a process initiated by the federal government's environmental laboratory and science centre.

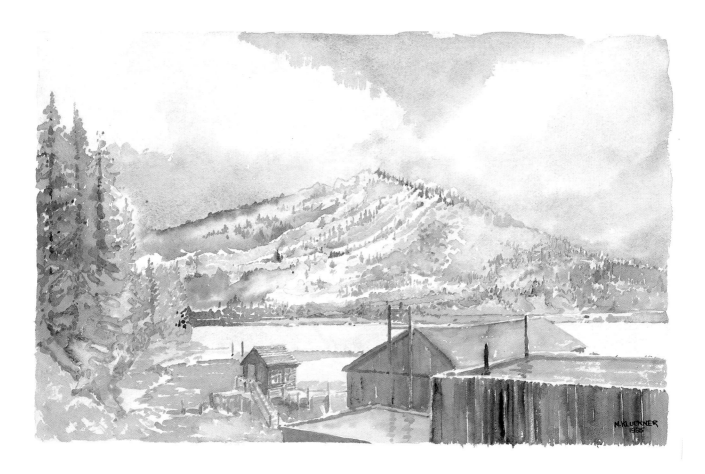

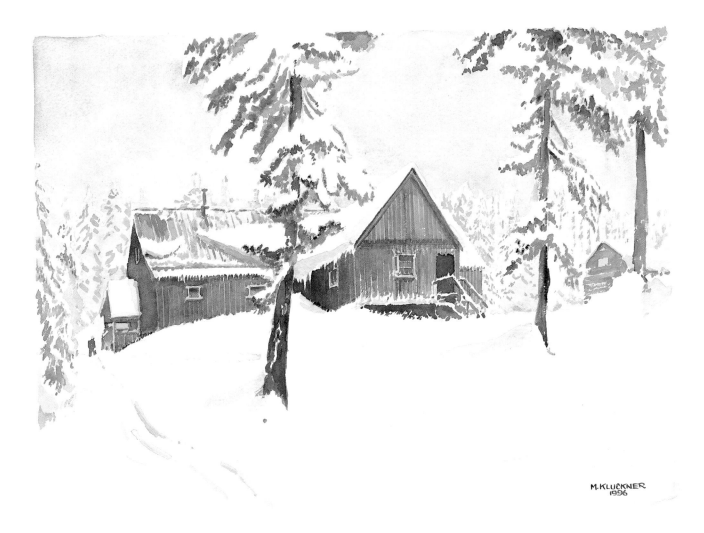

M. KLUCKNER
1996

HOLLYBURN LODGE

A far cry from the elegant, sophisticated facilities of downhill-skiing mountains like Grouse and Whistler/Blackcomb, rustic Hollyburn Lodge caters to the cross-country skiing crowd. Erected in 1926 by three Swedes who scavenged lumber from some abandoned sawmill bunkhouses and hauled it a mile up the mountain, the lodge sits beside First Lake, a clearing in the middle of the gloomy, mystic alpine forest. Trails radiate from it into the woods and along the ridges, occasionally offering views onto the city far below.

FOLLOWING PAGES

VIEW FROM KEITH AND SAL'S

Unlike amphitheatres built by humans, where the cheap seats are up high, in the North Vancouver amphitheatre the home prices increase with proximity to the deity. Residents of the streets above Edgemont Village, not far below the base of the Grouse Mountain chairlift, enjoy a stunning panorama across their neighbours' rooftops toward the harbour and the downtown, with the city's suburbs and the Fraser delta as a backdrop.

TWENTY-SECOND NEAR QUEENS

A dramatic point on West Vancouver's hillside is the top of Twenty-second Street near Queens, with the towers of the Dundarave waterfront, English Bay, Stanley Park, and the city of Vancouver spread out below. The Upper Levels Highway cuts across the Hollyburn hillside a little higher up and divides the newer West Vancouver of winding streets and developments like the British Properties from the grid of streets below.

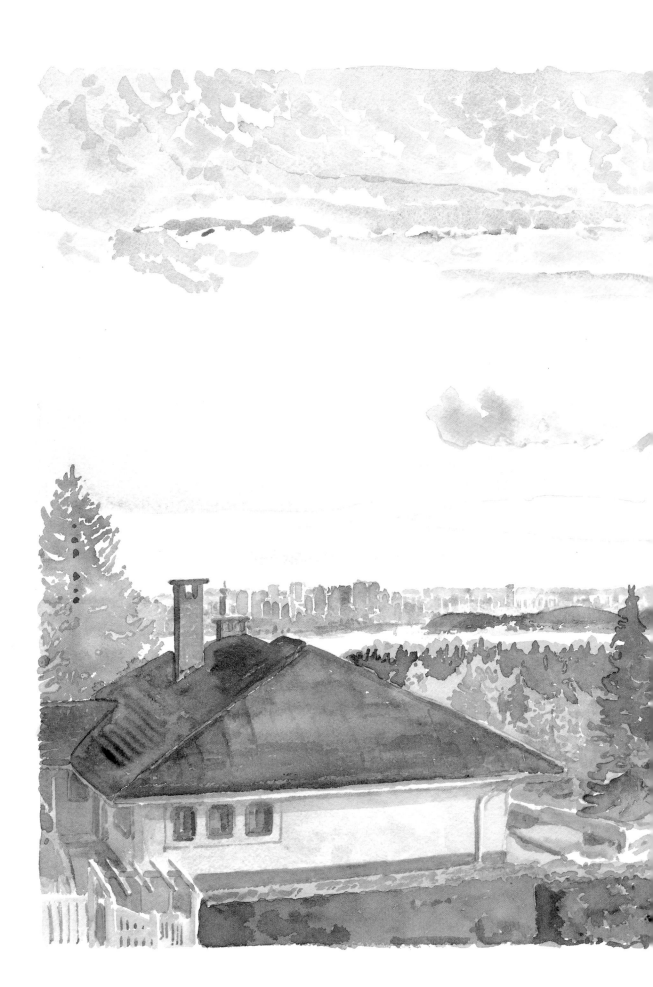

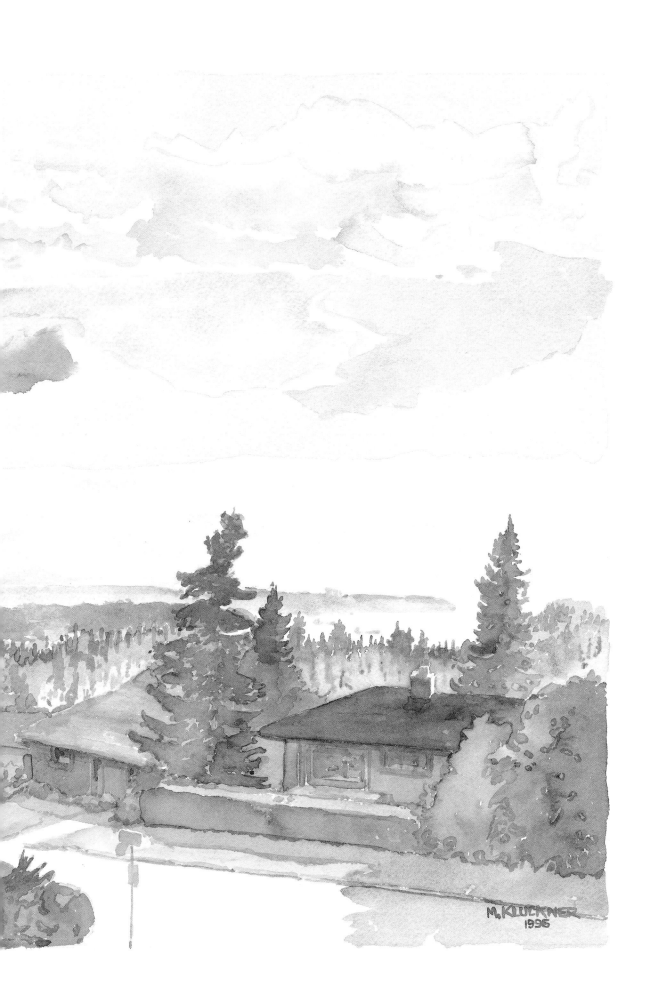

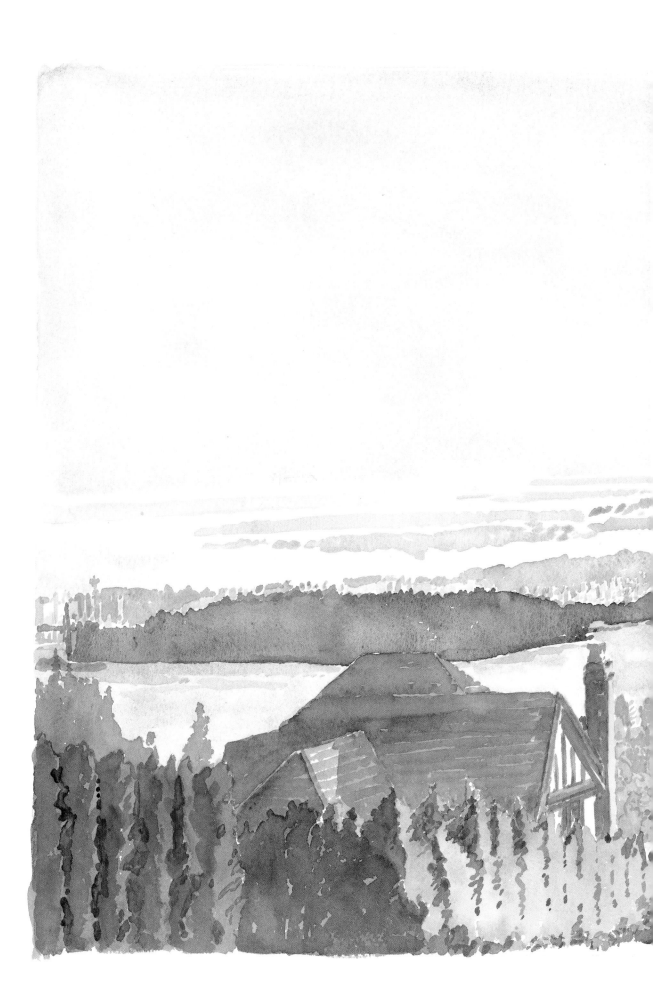

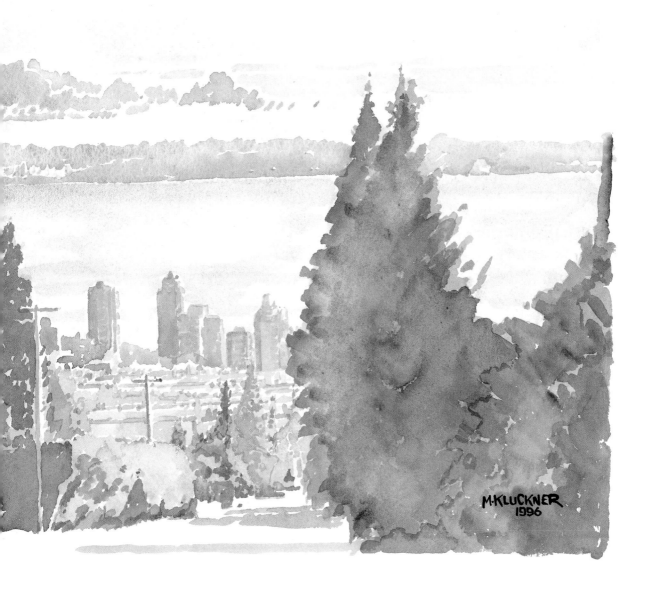

The River and the Valley

Few cities offer the contrasts of Greater Vancouver – an extraordinary waterfront and a recreational harbour nonpareil, dramatic mountains, and a fertile valley extending for more than 100 kilometres to the east. The dividing line between the hilly and the flat is the Fraser River – in aboriginal and early colonial times the highway connecting the coast with the interior and, more recently, British Columbia's all-purpose salmon-spawning stream, industrial site, and sewer.

South of the river the landscape opens out into a broad delta; toward its mouth, the fertile silt it deposited over millennia supports much of the province's truck farming and, in defiance of historic flood levels, the international airport and nearby Richmond with its large buildings cowering behind the dikes. The Fraser River defined the location of New Westminster, whereas Vancouver is a child of lumbering and shipping and the railway. Until the freeway opened through the valley in the mid-1960s, New Westminster was the farmers' city, with a big produce market and larger stores than those of valley agricultural communities like Langley and Ladner; subsequently housing sprawled across the valley, and New Westminster was largely bypassed by the traffic that had quick access all the way into downtown Vancouver.

Today, along the banks of the river upstream from the metropolis, small sawmills occupy some backwaters, fishboat harbours others. Recently the Greater Vancouver Regional District has bought up a lot of shoreline, especially on the south side of the river, to preserve as natural parkland. Sandbars, like the Two-Bit Bar in Langley's Glen Valley, still provide tolerable fishing and quiet reflection for a cadre of year-round anglers.

Toward the mouth of the Fraser the riverbanks become crowded with heavy industry and the river with log booms and sawdust scows pulled by sturdy tugs. Freighters make their way up the south arm, past Steveston's historic canneries and the quaint fishing community at Finn Slough, to a docking complex on the Surrey side of New Westminster. But even along the Richmond foreshore, in Delta and on Westham Island in the middle of the south arm, there is still farmland, punctuated by the neat rows of trees and hedgerows full of song-

birds that predated the arrival of the railway and the rise of the city of Vancouver. That flatland, with its dikes, views of the turgid river, herons fishing the flats, and crowds of seabirds, faces westward onto the Strait of Georgia; on windy days the sky clears off except for cumulus clouds floating many miles to the west above Vancouver Island's mountains.

For thousands of years aboriginals used the river and its tributaries through the valley on their regular seasonal rounds from foraging place to fishing spot to wintering place, for trade, ceremony, and war. European colonizers arrived in the 1820s and established a fort on the river at Derby Reach in Langley as a centre for fur-trading operations. A natural prairie a few miles to the south, now called Milner, was cultivated to provide the fur-trading operation with sustenance and edible exports in addition to the salted salmon shipped from the fort in barrels.

The first organized attempt to establish a yeomanry dates to the years just before the First World War and the plan by the London-based B.C. Electric Railway Company to service agricultural communities with an electric railway connection between Chilliwack and Vancouver. Many enthusiastic English families arrived and began to farm, but as early as the mid-1920s the company noted that much of the good land was being held by speculators. Construction through the valley of all-weather roads in the 1920s, and the development of affordable pickup trucks, curtailed the railway's profits; only the dawn milk runs into the metropolis made use of the railway's potential. In the long run, though, the fate of the early Fraser Valley family farms is best described by Will Carleton's couplet from "The Tramp's Story": "Worm or beetle, drought or tempest, on a farmer's land may fall, / Each is loaded full o' ruin, but a mortgage beats 'em all."

Many urban Vancouverites are unaware of the food grown on their eastern and southern doorsteps, as are suburbanites who, since the Second World War, have moved onto what was once agricultural land. Modern long-distance trucking has, in the minds of many, made Lower Mainland agriculture irrelevant, and for a time it seemed as if most of the good farmland would end up paved for housing developments. Cheap American and Mexican vegetables allowed Lower Mainlanders to concentrate on their historic first love – land speculation. Nevertheless, the rural areas have thus far continued to survive, in some areas due to the horse culture, in others through a new, better-financed version of the family farm, where llamas or sheep or milk goats or bees provide a mixture of money and recreation for the farmer. In the tradition of British Columbia subsistence farming, someone in the family usually has a cash income from a job or investments in the "evil" city.

For nine months of the year the Fraser Valley is a bucolic, pretty place, a rare example in British Columbia of settled countryside – the sort of landscape of small farms and mixed buildings that is common in eastern Canada and, ironically, in the American counties bordering the valley. Spring is lambing and calving time; the grass is bright green, rich and thick, speckled in April with dandelions, and the ewes and cows wander ponderously about, their udders swaying, while their babes gambol and frisk and bask in the warm sun. Later in the spring, as the days stretch on into the evening, the berry crops come in, and in the fields around Abbotsford East Indian farm labourers sweat and

BRITANNIA SHIPYARD

The Britannia Shipyard on the Steveston waterfront, dating from the beginning of the 20th century, is undergoing a slow restoration, largely carried out by volunteers who wish to keep alive the West Coast tradition of wooden boat building. Set on pilings sunk into the mud near the river's low-water mark, the sheds have frames of heavy timber and sheathing of galvanized iron. Another landmark a few hundred metres downstream is the century-old Gulf of Georgia Cannery, recently restored, opened to visitors, and declared a national historic site. Salmon canning, first established on the south arm of the Fraser River at Annieville in the early 1870s, was one of the significant early industries of the Lower Mainland, benefitting from technological advances in fish steaming and can soldering, as well as reliable shipping to faraway markets, especially England.

stoop and pick. The milk cows in the valley are almost universally holsteins; here and there are Jersey herds, whose owners insist defiantly that cows are like televisions: once you've had a coloured one you'll never go back to black-and-white. In the sticky heat of August, with the weather much hotter than on the coast, the corn and grain crops ripen, as does a second hay crop on the unirrigated meadows. Fall brings the last harvest – pumpkins and lavender-coloured cabbages, fields of golden barley and wheat straw. And then the rains come.

Until recently, when long-distance commuting began in earnest, the outer reaches of the valley were lonely, quiet places in the winter. In this bleak landscape east of the snow line defined by the ocean and the warm city, it was not uncommon for storms to push snowdrifts across roads, killing unlucky travellers navigating the Trans-Canada Highway across the Sumas Prairie. But unlike the North Shore mountains, which still regularly claim hikers and skiers who stray too far from the established paths, the Fraser Valley has been tamed; today the greatest threat comes from a fellow motorist intent on using his cellular phone or changing a CD.

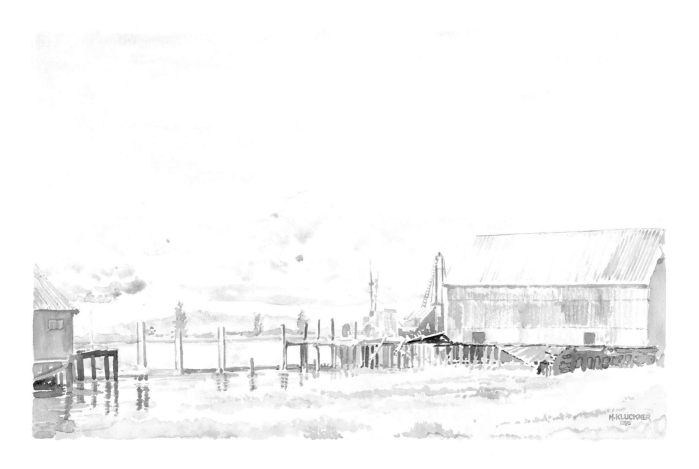

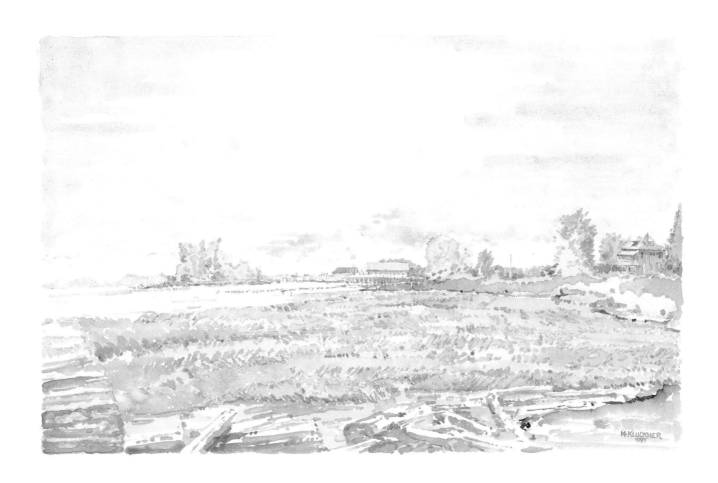

STEVESTON

Along the banks of the south arm of the Fraser River, which flows slowly from the forks at New Westminster to the sea, patches of natural reeds and grasses are interspersed with evidence of human activity. Pilings dot the river's edge, the remains of wharves built by farmers a century or more ago to ship their grain and produce; some farms, including a few at considerable distance from the river, had sloughs (since dried up or filled) connecting them with the river, making the construction of a wharf unnecessary. Scattered logs, blown ashore from broken booms, provide firewood for enterprising foragers. I sat with my back against one such drift log near the foot of Number Two Road and looked toward the boat-building sheds and cannery buildings of Steveston, a 19th-century fishing settlement that grew so big on the proceeds of its single industry that it was dubbed Salmonopolis. It was a May day with a warm sun but a bitterly cold wind off the Strait of Georgia, which rippled the sedges and reeds along the riverbank like the fabled summer winds whistling through prairie wheatfields and grasslands. On days such as this the Lower Mainland is very English, and residents are wise to heed the ancient saying "Ne'er cast a clout before May's out" (remembered either as don't take your clothes off before June, or don't take them off before the May tree – the hawthorn – blooms).

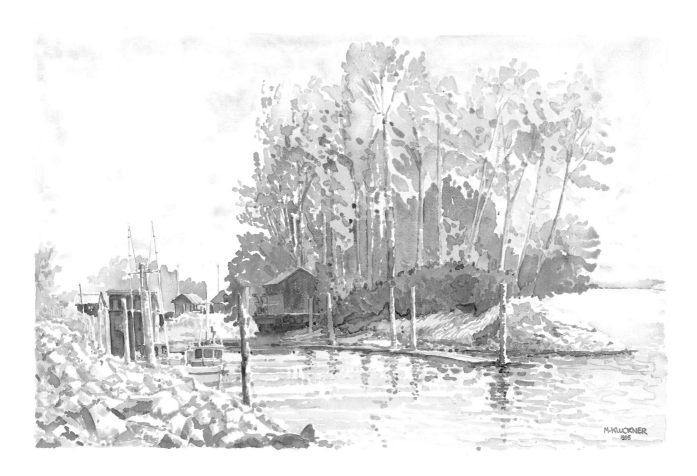

FINN SLOUGH

The last of the Fraser River's historic fishing commu-
nities clusters along Finn Slough near the bottom of
Number Four Road in south Richmond. A pic-
turesque collection of little shacks on pilings, scows,
and fishboats, interconnected by narrow bridges and
board walkways, the slough was, not surprisingly, an
enclave of Finns, part of the Lower Mainland's ethni-
cally diverse past, which saw the fields bordering the
slough farmed by Englishmen and Steveston's streets
and businesses develop with a distinctly Japanese cast.
Finn Slough seems especially quaint today, as there is
no provision for automobiles, and the scale of the cot-
tages, and the paths and spaces in between, is wide
enough only for humans and wheelbarrows. The
watercolour looks into the slough, with the Fraser
River on the right.

SAWMILL ON BEDFORD CHANNEL

Along the Fraser River a few old lumber mills, puny compared with the giant
operations of today's multinationals, continue to fill the air with the sweet smell
of sawn cedar. The mill on Bedford Channel in Fort Langley has a very sheltered
location for its booming ground; the channel, kept open by regular dredging,
separates McMillan Island on the right from the village of Fort Langley. The view
looks downstream toward Derby Reach from the bridge crossing the channel and
shows what is a typical small cedar mill: log booms strapped together in the quiet
water, groups of pilings driven into the river silt at a slight angle and lashed
together at their tops for stability, a collection of shacks and huts for the saws and
the green chain, a log pond at one edge of which a curved chute with a toothed
conveyor lifts the logs out of the water toward the saws above, and a conveyor
belt to move sawdust away from the buildings. The big change from the old days
of a few years ago is the lack of a dome-topped sawdust burner and the signature
plume of smoke that represented, according to former B.C. politician Phil
Gagliardi, "the smell of money." These days the sawdust is dumped into a barge
until it becomes an orange cone threatening to overflow, and is then hauled off
by tug to become something useful, perhaps Prest-o logs. Derby Reach is the site
where, in 1827, the Hudson's Bay Company built its first fort; because it was
prone to flooding and too far from the company farm at Milner, a second fort,
the one restored and rebuilt as Fort Langley, was erected in 1840. The aboriginal
village on McMillan Island has been home to the Sto:lo people only since Fort
Langley was established there, although there were villages in the area dating back
perhaps 10,000 years and a rich archaeological legacy yet to be explored, not least
of which is on the Fort Langley site itself. Not surprisingly, Europeans chose a
site that had also been strategic for earlier inhabitants.

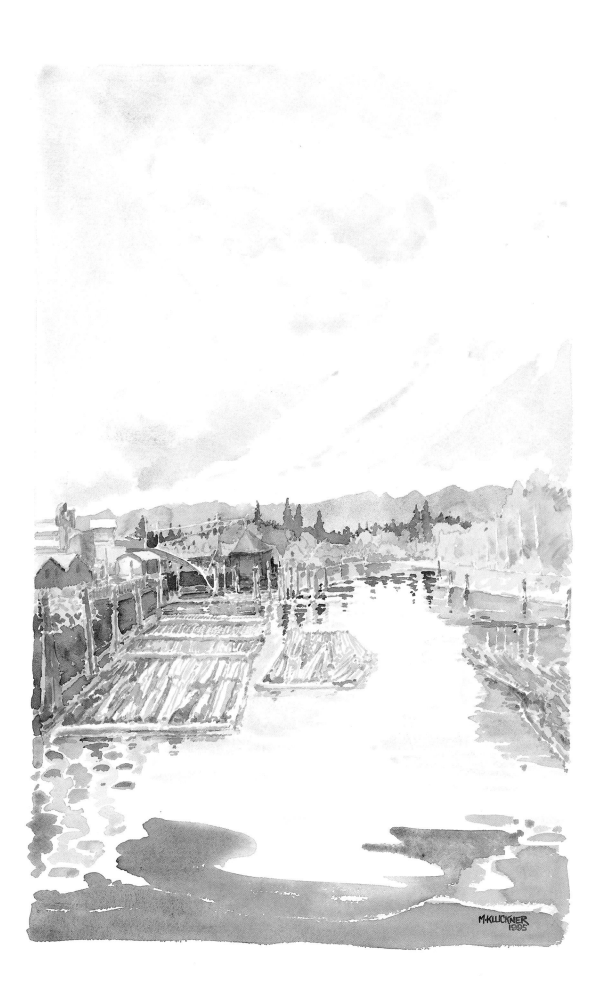

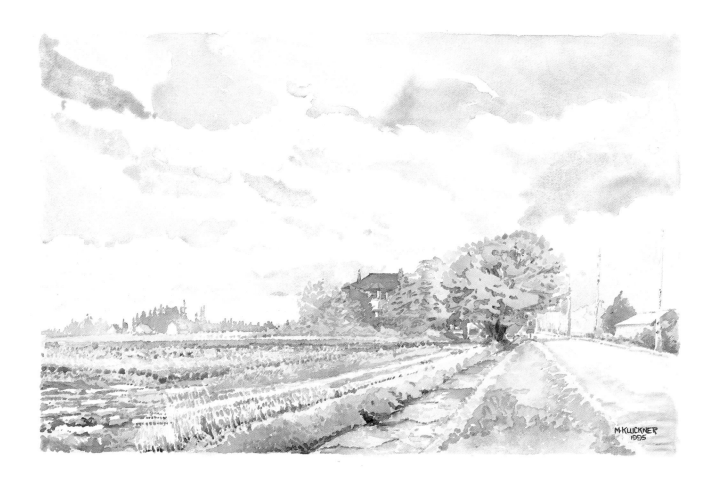

CABBAGES IN A DELTA FIELD

The flat rectangle of alluvial silt in Delta bounded by the Strait of Georgia, the Fraser River, the old Ladner Trunk Road, and the highway to Tsawwassen contains some of the most productive farmland in British Columbia and is a scene where the sky, the earth, and the water almost literally meet. This great plain, with its neatly plowed furrows, is punctuated here and there by farmhouses, some dating from well back into the 19th century, and clusters of trees planted around them for windbreaks and decoration many years ago. Like the Canadian Prairies, Delta is a sky watcher's place, with the incoming clouds visible long before they darken the sky. It is also a comparatively dry place, receiving little more than half the rain endured by downtown Vancouver. In the fall the deep, straight ditches along the roadsides are full of water alive with algae growing enthusiastically in the seepage from the manure-rich fields. Fields are platted in coloured squares and rectangles separated by dark hedgerows, like a Mondrian painting: blue-greens and purples of cabbage, gold of corn stubble, orange of pumpkin, grey of mud.

PUMPKINS

A worthwhile crop on an otherwise fallow field, pumpkins add orange to the autumn palette of distant blues and faded greens and golds. Increasingly the Halloween jack-o'-lantern market is a U-pick one, with the farmers doing the retailing and city children seeing pumpkins where they are grown. Some farmers sow a part of a field with Atlantic Giants, the behemoths of the edible vegetables, like those in the foreground of the painting. In the distance is the Lower Mainland's Mount Fuji – Mount Baker – the most northerly of a chain of volcanoes that includes Mounts Rainier, Shasta, St. Helen's, and Hood. It is on American soil, south of the Fraser Valley's Sumas Prairie.

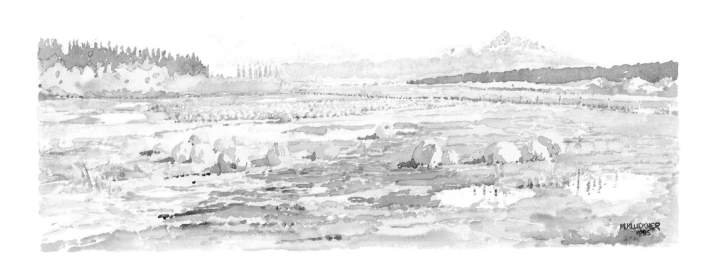

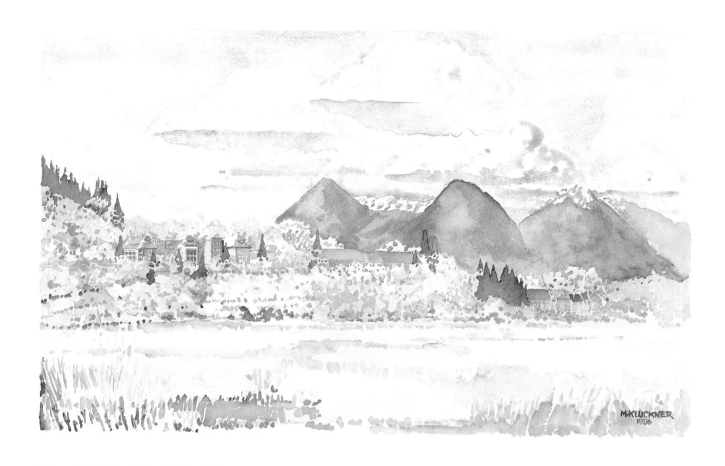

ESSONDALE FROM COLONY FARM

City youth left Vancouver in the sixties along the Lougheed Highway for one of two reasons: country cousins, in the little chicken farms and bungalows of Haney or Websters Corners or Mission on the north side of the Fraser River; or the road-racing track on the Westwood Plateau in Coquitlam, where Mini Coopers and Lotus Super Sevens clawed their way around a tight circuit set into the forested hillside. At the time the built-up city ended in Burnaby, not far past the Brentwood Mall, and the Lougheed Highway then traversed kilometre after kilometre of stump farms and patches of alder scrub. Past Maillardville the highway swung slightly to the northeast, bringing the spectacular peaks of the eastern valley mountains into view. Then, suddenly, the red-brick buildings and hipped-roof cottages of the Riverview Psychiatric Hospital appeared on the left, like a town, a world unto itself. The painting shows the view today from Colony Farm, across the Lougheed Highway. The building farthest to the right, Crease Clinic, sits almost on the highway – a huge, patterned-brick, prisonlike edifice with barred windows, a vision of incarceration "at the pleasure of the lieutenant governor" that made us shudder as we drove by on our way to a pleasant afternoon of motor sports at Westwood. In the foreground Colony Farm stands abandoned, a once useful piece of landscape awaiting the rethinking of society's objectives. The subdivisions have closed in all around it, and even the Westwood circuit has succumbed to them.

PATHWAY AT RIVERVIEW

Although they financed their efforts without the benefit of income taxes, Canadian governments in the early years of the 20th century nonetheless produced an astounding number of venerable landmarks. One such is the provincial psychiatric hospital at Essondale in Coquitlam, known as Riverview since the 1960s and the only monumental collection of architecture ever built in the countryside east of Vancouver. But the psychiatric hospital is more than just a cluster of massive edifices; on the grounds around the hospital buildings a few professional gardeners and an army of patients created the first botanical garden in western Canada (the third in Canada). The provincial government had purchased 400 hectares at the confluence of the Coquitlam and the Fraser Rivers in 1904, and over the next decade laid out a hospital for the insane. A quarter of it, above the Lougheed Highway, became the botanical garden and hospital site, while the balance between the highway and the river was Colony Farm – now the province's forensic psychiatric institute. The 1904 annual report of the hospital suggested that Colony Farm could easily produce "all necessary vegetables for the Hospital, fodder for the horses and hogs, all dairy products by the maintenance of a large dairy herd and the supply of fuel for the baker and for the boilers in summer." The report went on to note that, in addition to effecting great economies in the operation of the place, "much pleasant and healthy occupation" would be secured by the patients. The huge West Lawn Building, the corner of which is shown here, opened in 1913, by which time the botanical garden was laid out and partly planted; the equally large Centre Lawn Building visible in the background opened in the 1920s. Clearly the government felt that outdoor work – in particular, horticulture – was good therapy, a belief also held by many Vancouverites, although by the 1980s volunteer groundskeeping by patients had been phased out, following one patient's demand for wages. The trend by governments throughout North America toward deinstitutionalizing mental patients has thrown the future of the Riverview buildings and the now-mature botanical garden into doubt.

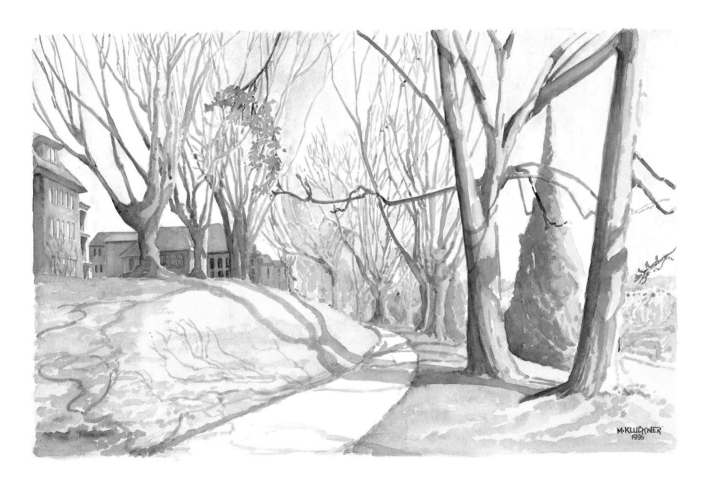

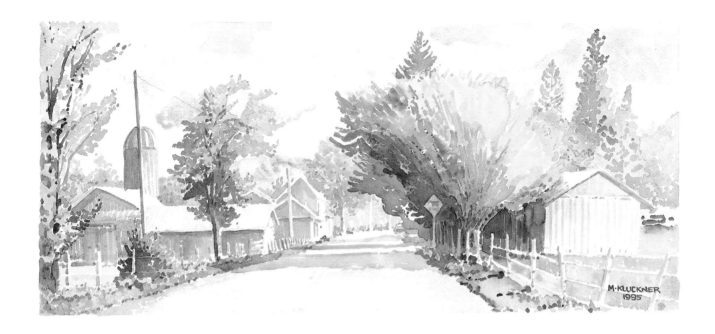

NORTH LANGLEY FARM

Craigintenney Farms was established in 1911 and is an
Ayrshire cattle operation on Allard Crescent just west of
Fort Langley in the Fraser Valley. It is unusual for a west-
ern Canadian farm in that its buildings are bisected by a
public road – a common enough occurrence in Europe, for
example, where everything clustered around thoroughfares
and what little traffic there was travelled at a walk. Such
was the case, no doubt, in that part of Langley until quite
recently when a popular park opened on the bank of the
Fraser River not far away, and large numbers of people
from the nearby subdivisions started to go for weekend
drives in the country. The watercolour was painted in the
early spring when dandelions carpet the grass and the
young leaves and grass are a vibrant green.

THE LEADEN SEA OF EARLY WINTER

In the distant future, when local people look back at the waning years of the
20th century, they will hail the wisdom of one great decision: to preserve
Boundary Bay as waterfowl habitat. For Boundary Bay, with the adjacent wet-
lands, pastures, and islands in the Fraser River Delta, comprises the major
stopover for the migrating millions of birds on their flight between the Arctic
and their next stopover in San Francisco Bay. The watercolour looks south
across Boundary Bay toward Mount Baker from a spot near the end of 112th
Street in Delta, near the Oliver Pumping Station, part of the drainage system
that keeps Delta partially above water during the winter (and named for John
Oliver, the farmer who first came to public attention in the early years of the
20th century for his innovative proposals to dike and drain Fraser Valley farm-
land, and went on to become British Columbia's premier during the 1920s).
Regularly, among the huge flocks of seabirds on the bay, a few responding to
some unseen signal will rise up and prompt a mass flight of thousands of their
kind; the leaders twist and loop as they fly over the glassy water, their wings
sometimes catching the light, while the followers loop and twist along the same
path like the twirling banner of a rhythmic gymnast.

MIST OFF MILNER FIELDS

Ground fog lends an eerie quality to the Fraser
Valley landscape. At dusk in the summer and
fall, especially after sunny days, fog rises off the
fields and hangs in the moonlight. It is still
there when the dawn's early light catches it, but
as the daytime heat increases, it retreats to the
shadows among the trees.

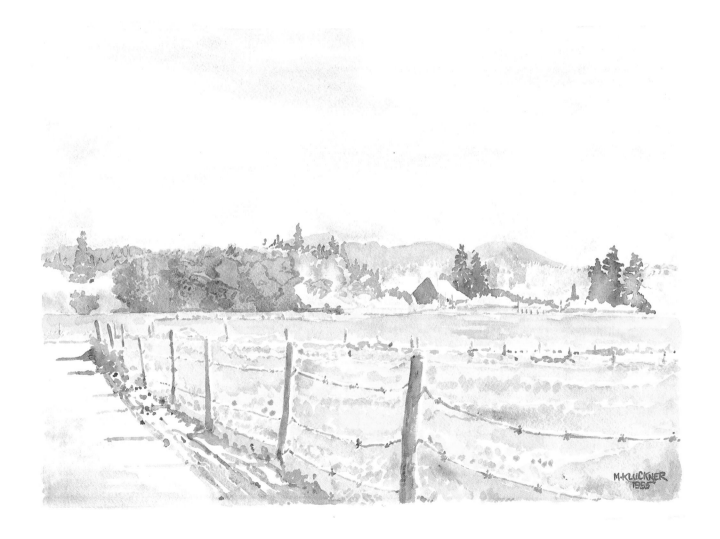